POSTCARD HISTORY SERIES

Madison

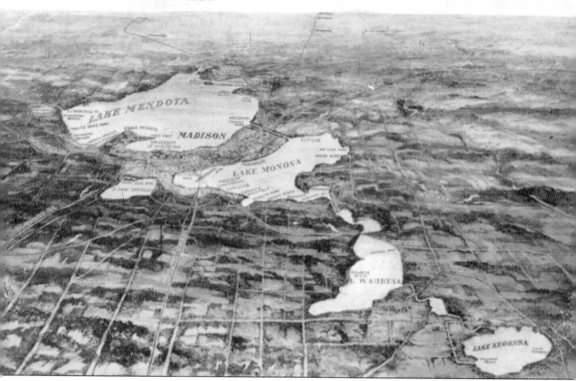

This bird's-eye view was published around 1900. The city's neighborhoods extend as far east as Elm Side and as far west as Vilas Park. Nakoma has yet to be settled. An 1832 survey named the waters, "Lakes First thru Fourth," and Wingra was noted as "a pond." Developer Leonard Farwell proposed their present names in 1854.

On the front cover: The second capitol building is seen from Monona Avenue (Martin Luther King Jr. Boulevard) around 1900. Fire destroyed the second capitol in February 1904. To the left are the Elks lodge (far left), the Avenue Hotel, and the village-era Mills business block. (John Powell collection.)

On the back cover: Please see page 63. (John Powell collection.)

POSTCARD HISTORY SERIES

Madison

David Sakrison

ARCADIA
PUBLISHING

Published by Arcadia Publishing
Charleston, South Carolina

Printed in the United States of America

Library of Congress Control Number: 2009931250

For all general information contact Arcadia Publishing at:
Telephone 843-853-2070
Fax 843-853-0044
E-mail sales@arcadiapublishing.com
For customer service and orders:
Toll-Free 1-888-313-2665

Visit us on the Internet at www.arcadiapublishing.com

To Ingrid and Robin. And to God, who gave us the gift of words.

CONTENTS

ACKNOWLEDGMENTS

No author ever works alone. I extend my deepest gratitude to the following: Jeff Ruetsche at Arcadia Publishing, for his encouragement, his invaluable assistance, and his patience; Abigail Cape, my able and hardworking research assistant; the staff at the Wisconsin Historical Society for their help and advice; proofreader Amanda Freeman for her able assistance; You, my readers—where would I be without you? And my wife, Christal, who assisted and supported this project in so many ways. Whatever success this book may have, I owe to these people and to others. Thank you. Whatever its shortcomings, they are mine alone.

All the postcard images in this volume are from the private collection of John Powell of Cashton. My thanks to John for proposing this book and for giving generously of his time and knowledge.

INTRODUCTION

Native Americans occupied the land around the four lakes for at least 2,500 years. Between 400 and 1,300 AD, a culture that thrived here built thousands of conical and effigy mounds throughout what would later become Wisconsin. The first white men to explore and exploit the four lakes area were French fur traders who arrived in the mid-1600s. They found the area dotted with Native Americans' villages and cornfields. Early forts at Green Bay and Prairie du Chien solidified the European presence in Wisconsin, and with the 1763 Treaty of Paris, the British became the dominant force in the region. Britain's defeat in the War of 1812 saw Wisconsin—then part of the Michigan Territory—and its forts and trading posts pass to American control.

In 1828, Native Americans ceded southwestern Wisconsin to the United States, opening the region for lead mining and farming. That same year, the U.S. Army established Fort Winnebago at Portage, and a lead miner, newly arrived from New England, camped on the isthmus, near what would later be the capitol park, on his way to Portage. The miner, Ebenezer Brigham, noted the area's natural beauty and predicted that a city would someday grace the isthmus. Two other white men passed through the four lakes area in 1829: Jefferson Davis, who would later become president of the Confederacy, and James Doty, a judge for the Michigan Territory. At that time, there were Ho-Chunk camps and villages all around the lakes though none on the isthmus proper. And while a few French and American fur traders had settled to the west near what is now Middleton, only one ramshackle trading post stood on the isthmus, near the present site of the Masonic temple on Wisconsin Avenue.

The Black Hawk War ended with the 1833 Rock Island Treaty, forcing the Winnebago Indians to give up their ancestral land in south-central Wisconsin and prohibiting any Winnebago from living in the four lakes area after June 1, 1833. This prohibition was widely ignored within a few years.

After the first comprehensive survey of the four lakes area in 1834, land that later became the heart of Madison went on sale at the Green Bay land office for $1.25 an acre. Doty was one of the first buyers and eventually laid claim to most of the land on and around the isthmus. In July 1836, Doty drew up the first plat of the town of Madison, named for James Madison, the fourth president of the United States. Doty's plat was conceived with more enthusiasm than expertise, and its shortcomings have bedeviled the city's planners and visionaries ever since.

In 1836, territorial delegates met in the town of Belmont to choose a territorial capital. After several other sites failed by just one vote, Doty secured the prize for his newly platted Madison. At the time, his shining "City of the Four Lakes" had no permanent residents.

The first permanent settlement on the isthmus was an inn, Peck's Tavern, later renamed Madison House, which was built in 1837 in the 100 block of South Butler Street. The cornerstone for the territorial capitol was laid on July 4 of that year.

The town grew slowly, due in part to the financial panic of 1837 and the depression that followed. Madison became a village in 1846, a year after the first capitol building was finished. King Street was the main business district and one of the few passable streets in the plat.

Wisconsin's statehood (1848) and the state's constitutional requirement for a university located in or near the capital city helped fuel a rapid expansion of the village. By 1856, when Madison became a city, it had a telegraph line (1848), a county courthouse (1851) and jail (1853), university buildings (North Hall in 1851 and South Hall in 1855), several churches, new business blocks, several fine brick mansions, a railroad line from Milwaukee (1854), gaslights on the capitol square (1855), and nearly 9,000 residents.

Most of the postcards in this book were published between 1898, the year the U.S. Postal Service first authorized the use of private sender postal cards, and the 1930s. During that period, Madison's population grew from 19,000 in 1900 to 57,000 in 1930. It was the golden age of parks development and grand ideas for the capital city. It was, according to authors Stuart Levitan and David Mollenhoff, the end of Madison's "formative years"—a time when all the forces and factors within it were coalescing into the great city it would become.

John Powell's impressive collection of postcards began with a BB gun and a transgression. He was 12 or 13 years old when he pointed his Daisy in the wrong direction and bagged a window of the family garage. His father, deciding that marksmanship was probably not Powell's surest path to a clean and upright life, took the boy to a local rummage dealer, where he chose a box of old postcards in trade for his disgraced popgun. He has been collecting postcards ever since—for more than 50 years. His files contain, he thinks, somewhere around 5,000 postcards (he says, "I used to have a lot more"), including 2,000 of Madison.

The postcards presented here advertise Madison's pride in itself. They proclaim its accomplishments and successes in the early years of the last century. If the city's shortcomings, failures, and setbacks are notably understated here, it is because these postcard images reflect the views of those who saw possibilities and opportunities where others might have seen obstacles and problems.

If most historical narratives are written by the winners, most postcards are published by the boosters and the optimists. The window on the past that these postcards present may be a bit rose-colored, but it offers interesting and illuminating sights nonetheless.

Enjoy the view.

<div align="right">

David Sakrison
May 2009
Ripon, Wisconsin

</div>

One

THE CAPITOL

The cornerstone for Madison's first capitol building was laid on July 4, 1837, with a celebration lasting several days—until the liquor ran out on July 6.

The territorial legislature convened in the building in early 1838, while hogs were quartered in the basement and the ink froze in clerks' inkwells. In 1840, an official report on the capitol construction said the building was little more than "a shell of a capitol," in dire need of extensive repairs. To complete the building on time, the builder had used wet wood and uncured plaster. A bill was introduced to move the territorial capital to Milwaukee and convert Madison's capitol building to a prison. It failed by a 16 to 7 vote.

By 1857, the town had become a city and the territory had become a state. The old capitol building was too small for the growing functions of the state government. In addition, it was generally considered a firetrap, shoddy, undignified, and unfit for a state capitol.

Construction of a new and larger capitol building began that fall. Costs and construction delays angered the legislators, and a bill to move the state government temporarily to Milwaukee was defeated in March 1858 by just one vote. The state used the old capitol building and rented office space in the new city hall at Mifflin Street and Wisconsin Avenue until the new one was finished in 1869.

Two new wings were added in 1882 to house the supreme court, the state library, the state historical society, and growing legislative staffs. Just 21 years later, the legislature approved construction of an even larger capitol building. Planning had barely begun when fire gutted much of the existing building in February 1904.

Madison's third and present capitol building was begun in 1906 and completed in 1917.

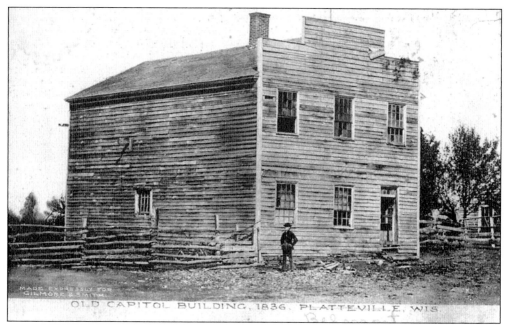

The Wisconsin Territorial Legislature met in this building in Belmont, near Platteville, in 1836 to decide on a permanent territorial capital. Speed was essential; Belmont was to become part of the new Iowa Territory in 1838. After a long and raucous fight, James Duane Doty's political maneuvering delivered the honor to Madison—a town that existed only on paper.

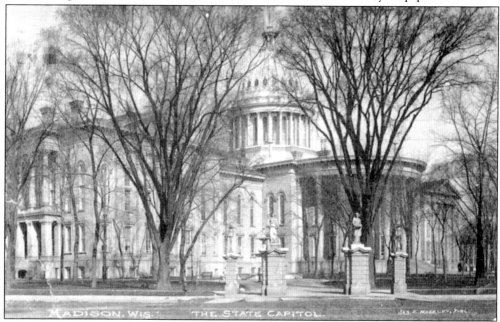

This postcard is of the second capitol building, completed in 1869 and expanded in 1883. Madison's first capitol building, completed in 1839, was a rather shabby affair, poorly built of wood and plaster. It brought accusations of fraud against Doty and the other capitol commissioners in charge of its construction. It was reviled as "lacking the dignity" befitting a territorial capitol.

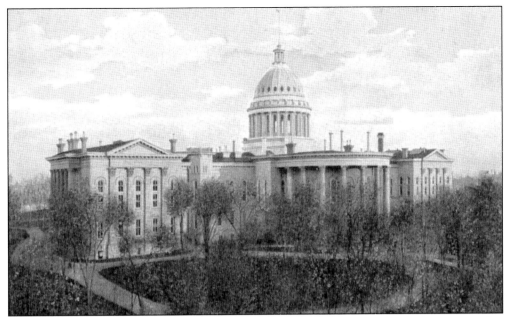

Construction of the second capitol building began in 1856 and was finished in 1869. That year, the building ended at the two towerlike structures shown midway across each side. A decade later, it was overcrowded, and work began on the two new wings seen in this view. By November 1883, the south wing was complete. Nearly finished, the roof of the north wing collapsed, killing five workmen and injuring 20.

From 1842 to 1872, a whitewashed fence surrounded the capitol to keep livestock off the grounds. In 1869, Gov. Cadwallader Washburn proposed an ornamental iron fence and landscaping to beautify the new capitol's rustic park. The existing sidewalk was inside the fence, so eight feet of street was taken over for a new parallel sidewalk outside the fence. Despite strong statewide opposition, the landscaping project went ahead.

The 1872 landscaping plan called for four fountains on the capitol grounds. Only one was built at the South Wisconsin (later Monona) Avenue entrance. The plan outlawed hitching horses to the new iron fence or anywhere else on the capitol square. That restriction gave rise to a new open-air market in the first block of East Washington Avenue.

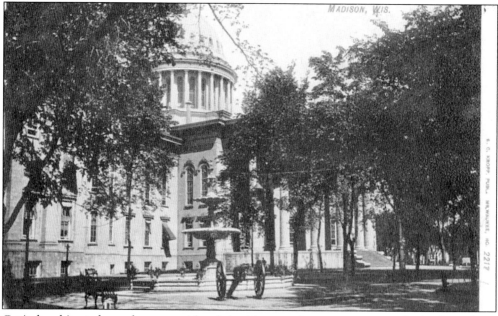

Capitol architects have always considered the Monona Avenue entrance to be its front door, with its splendid view of Lake Monona. Later planners, including architect Frank Lloyd Wright and parks commissioner John Nolen, envisioned a grand "government mall" extending from the capitol steps to the lakeshore. Their dream was only partially fulfilled with the opening of the Monona Terrace Community and Convention Center in July 1997.

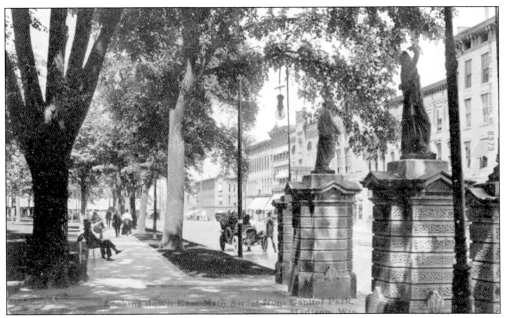

The capitol's iron fence was removed in 1899, and the sidewalk outside the fence was given back to the city to widen the street. The ornamental columns that anchored the gates remained in place. This view looks east down Main Street from the Monona Avenue (Martin Luther King Jr. Boulevard) gates, sometime between 1899 and 1906. Two-way traffic circled the square until June 1921.

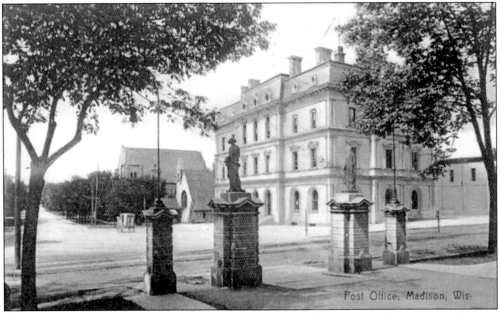

The post office and courthouse were built in 1872 at Mifflin Street and Wisconsin Avenue. With the 1858 city hall on the opposite corner, the intersection was the city's government plaza in the 19th century. Next to the post office is the 1886 Unitarian church. The post office was demolished in 1930 and replaced by Manchester's Department Store. The church was razed in 1951 for the store's parking lot.

This is Wisconsin's second capitol, viewed from North Hamilton Street about 1900. The 1872 landscaping placed a bandstand to the east of this corner, nearer to Monona Avenue (Martin Luther King Jr. Boulevard). The landscaping project ran over budget and was never completed. It did succeed in removing one unusual eyesore; a 500-ton coal pile on the capitol lawn was moved to a new underground bunker.

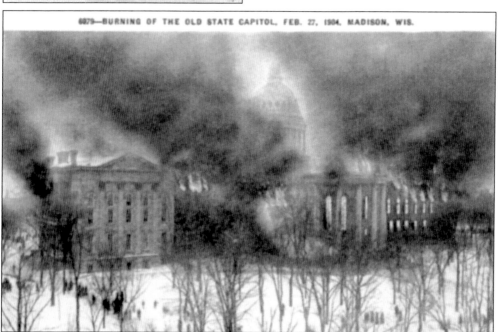

Around 3:00 a.m. on February 27, 1904, a gas lamp flared and ignited new varnish in the assembly cloakroom. The capitol had a state-of-the-art firefighting system, but the sprinklers were dry; the tank that fed them had been emptied for cleaning. Fire brigades fought the blaze for 16 hours while citizens formed human chains to pass documents and other items out of the building.

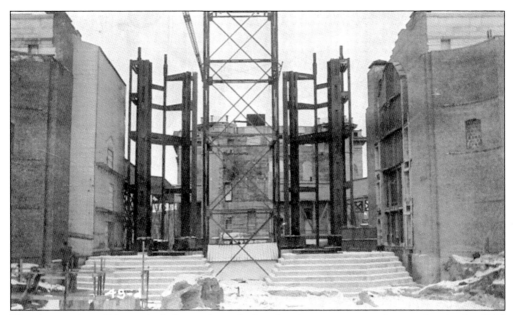

The destruction of the capitol, shown here during the cleanup, was nearly complete in the 1904 fire. The state had recently cancelled $600,000 of insurance policies on the building to save money, and the self-insurance fund contained only $6,000. However, few regretted the fire; the state had already begun planning for a new capitol, and construction began in October 1906.

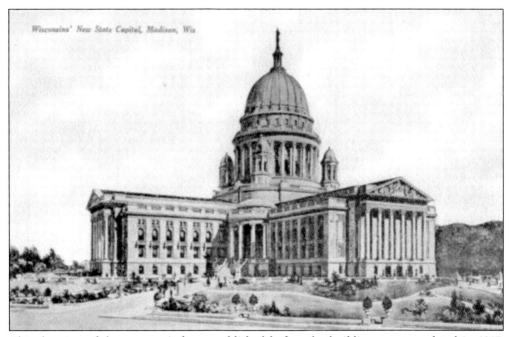

This drawing of the new capitol was published before the building was completed in 1917. The four turrets surrounding the dome were dropped from the plans. Most of the other details shown were built—at a final cost of $5 million, plus $7 million for furnishings. The new capitol was full the day it was finished. Within 10 years, every nook and cranny, including one women's lavatory, held state offices.

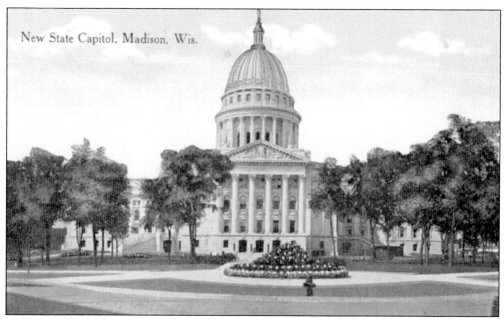

New State Capitol, Madison, Wis.

Budget woes spread construction over 12 years. The west wing was rebuilt first and opened to the legislature in 1909. Next came the east wing (1910), the south wing (1913), the rotunda and dome (1915), and the north wing (1917). The world's first electronic voting machine was installed in the assembly chambers in 1917. The dedication ceremony was delayed by World War I, and the new capitol was not officially dedicated until 1965.

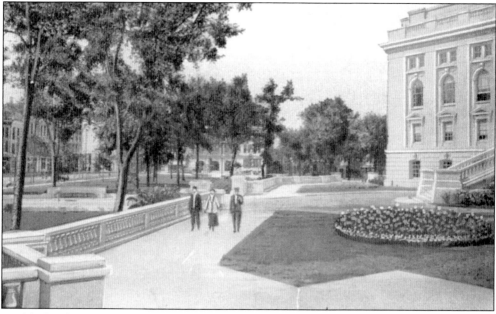

Marble for the new state capitol came from all over the world. The assembly voted to reject one shipment of marble intended for its own chambers. That stone was "unbecoming" of the assembly, the members said, because identical stone had already been installed in the capitol's washrooms. Main Street is at the far left, and the Park Hotel, remodeled in 1911, is in the middle background.

This postcard incorrectly identifies the statue as *Forward*. Her official name is *Wisconsin*. The 15-foot high, three-ton gilt statue was hoisted and bolted to the top of the dome, facing Lake Monona, on July 20, 1914. Newspaper editorials and letters to the editor had debated for weeks over which direction she should face. One writer suggested, "the majority of the city would vote to have [her] face toward some brewery."

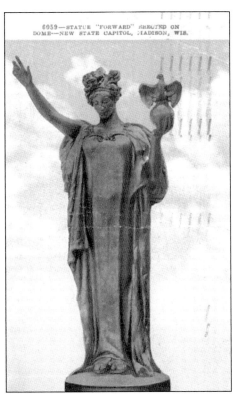

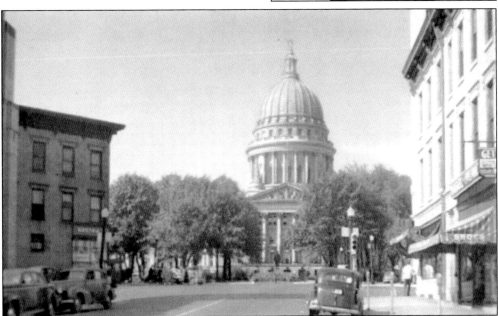

Upon completion, the dome was among the largest in the world. Only St. Peter's Basilica in Rome and St. Paul's Cathedral in London had larger ones. Wisconsin's capitol had the only granite dome in the United States. The U.S. Capitol's dome is iron, painted to look like marble. The official height of Wisconsin's capitol is 285.9 feet—19 inches shorter than the nation's Capitol. This view looks up King Street.

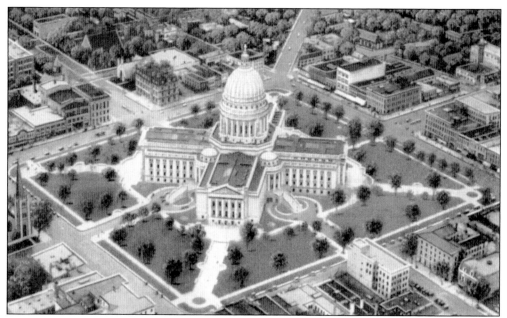

Around 1920, the 1858 city hall and the 1872 post office flank Wisconsin Avenue at the upper left. At East Washington Avenue and Pinckney Street are the 1871 Mason-Baker Block and 1854 Bruen Block, the latter replaced in 1922 by the First National Bank building. At 1 East Main Street stands the 1854 Pioneer Block, formerly the Vilas House, which was for many years one of the finest hotels in the state.

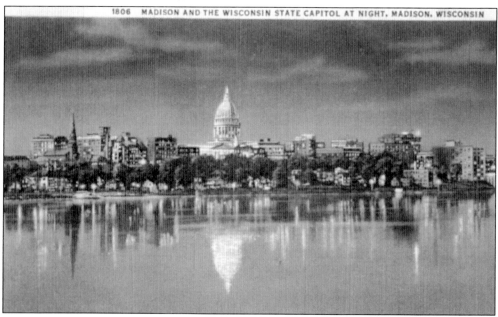

The capitol dominates the skyline in this view from Lake Monona. The 1881 steeple of St. Raphael's Church rises next to the 1886 Dane County Courthouse on West Doty Street. Behind them is the nine-story Gay (now Churchill) Building, Madison's first skyscraper, which was constructed in 1914 by developer Leonard C. Gay. It was the city's tallest building until the Belmont Hotel (to the right of the courthouse) was completed in 1923.

Two

THE SQUARE

The first buildings on the capitol square housed businesses supporting the work of the government—hotels to house the legislators, restaurants and taverns to feed them, and other, less-savory establishments for their entertainment. In the village period, before Madison became a city, King Street was the only defined street, and it remained Madison's principal business address for decades after the town's founding.

While the first territorial capitol was being built, the legislature met in the basement of the American Hotel, a three-story wood-frame structure erected in 1838 on the northeast corner of Pinckney Street and East Washington Avenue. That same year, two notorious gambling dens opened their doors on the square, the Tiger saloon just north of the American Hotel on Pinckney Street, and the Worser saloon at the corner of Pinckney and Morris (later Main) Streets, where the Tenney Building now stands. Other hotels joined the American Hotel on the square before the dawn of the 20th century, including the National Hotel in 1841, the Capitol House (later the Vilas House) in 1854, and the Park Hotel in 1871.

Statehood in 1848 and the draining of the marsh at the base of the East Washington Avenue hill brought a building boom to Madison in the 1850s, and the capitol square began to eclipse King Street as Madison's prime business district. Bruen's Block was built in 1853 on the southeast corner of Pinckney and East Washington Streets. The city offices and council chamber were there in the 1850s. By the time it was replaced in 1922 by the First National Bank building, Bruen's Block had firmly established 1 South Pinckney Street as one of Madison's most important and prestigious business addresses.

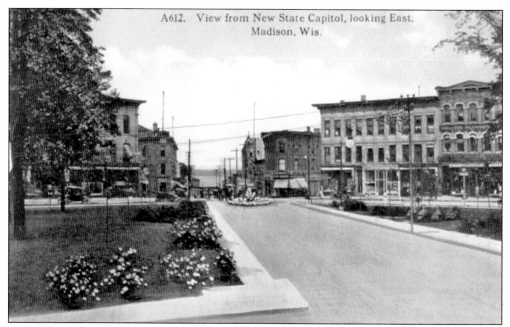

The postcard tour of the capitol square begins at King Street, the city's first business street. This view from the early 20th century shows the incomplete landscaping of the third and present capitol and the less-than-inspiring vista down King Street to "Machinery Row," a cluster of industrial buildings on the shore of Lake Monona.

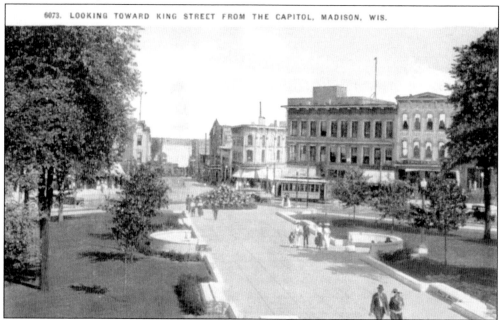

Several village-era buildings are visible here. On the corner of Pinckney and Main Streets is the 1853 Fairchild business block, replaced in 1955 by the S.S. Kresge Drug Store. Across Pinckney Street is the 1852 business block built by Simeon Mills and John Catlin, and down King Street is Mills's four-story 1855 business block. Those two buildings (104 and 106 King Street) still stand as the Simeon Mills Historic District.

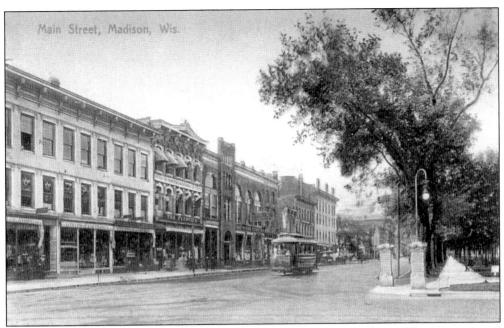

In the 1860s, the Fairchild Block at far left was home to the St. Julien Billiard Rooms and to Samuel Klauber's store. Klauber, who arrived in the 1850s, was Madison's first permanent Jewish resident and one of the city's leading merchants. At the far end of the block at 1 East Main Street stands the Vilas House, among the state's finest hotels when it opened in 1853.

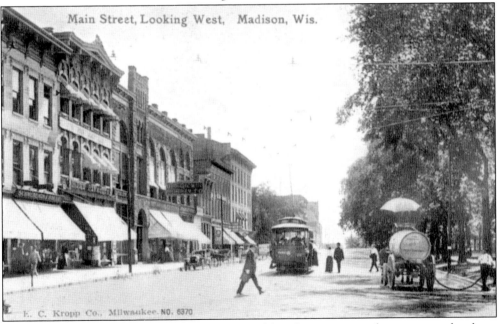

The Hotel Plymouth, at left, was one of several hotels on or near the square at the dawn of the 20th century. By 1910, even Milwaukee newspapers were conceding that Madison was Wisconsin's most popular convention city. Just a few years later, the advent of affordable automobiles and improved highways would bring an even greater tourism and convention boom to Madison.

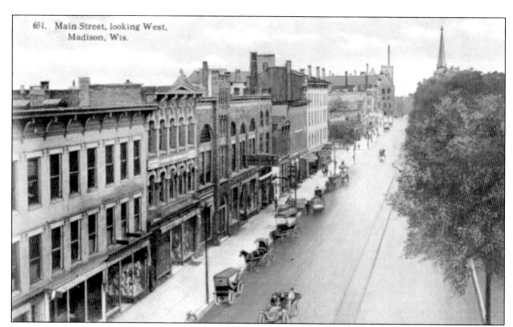

651. Main Street, looking West.
Madison, Wis.

In 1865, the first block of East Morris (later Main) Street became the city's first paved street, although it does not appear paved in this early 1900s view. As long as horses provided much of the locomotion in the city, even paved streets were muddy in wet weather and dusty in dry. Horse-drawn sprinkler wagons (see page 21) helped settle the dust but did little to diminish the mess.

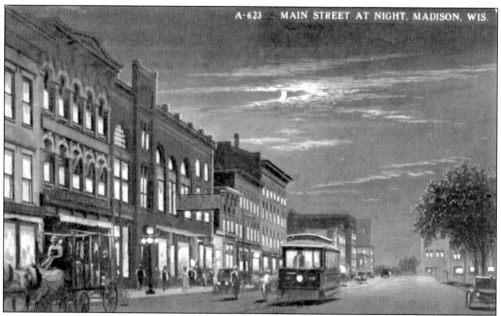

A-623 MAIN STREET AT NIGHT. MADISON, WIS.

This rather crudely hand-colored postcard purports to show Main Street at night. The photograph underneath all the hand tinting was undoubtedly taken during the day. Gaslights were first installed on the square in 1855. By the early 1900s when this postcard was produced, the fine hotels (and their dining rooms) and the many businesses on the square would have made it a cheerful and well-lit district after dark.

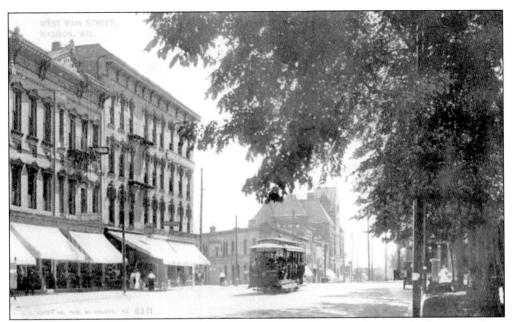

An open-air electric trolley car rumbles down West Main Street in this view looking west from Monona Avenue (now Martin Luther King Jr. Boulevard). In the background is the second Dane County Courthouse, completed in 1886 at Main and Fairchild Streets. Eighteen-year-old Frank Lloyd Wright worked for Allan Conover, the architect who supervised construction of the courthouse.

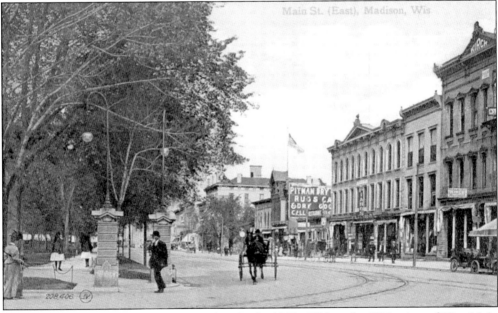

Morris Street became Main Street sometime in the 1860s. This early-1900s view of West Main Street looks east from in front of the Park Hotel. In the first decade of the 20th century, Madison annexed four important suburbs on the west side—University Heights, West Lawn, Wingra Park, and Oakland Heights—while the city's industrial base expanded east of the isthmus. The pattern of future development was set.

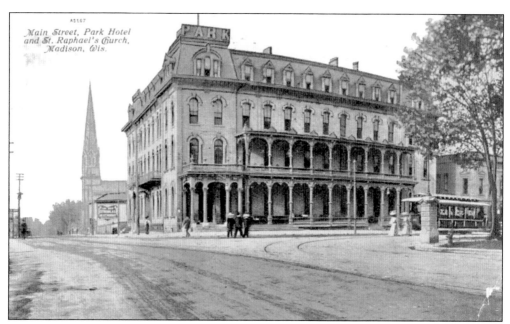

To lure the state government away from Madison, Milwaukee businessmen plied state legislators with Milwaukee-made whiskey, cigars, and of course beer, and with accounts of the superior amenities the "Cream City" offered. In response, a group of Madison's leading businessmen formed the Park Hotel Company, raised $100,000, purchased the lumberyard at Main and Carroll Streets, and built a new hotel there.

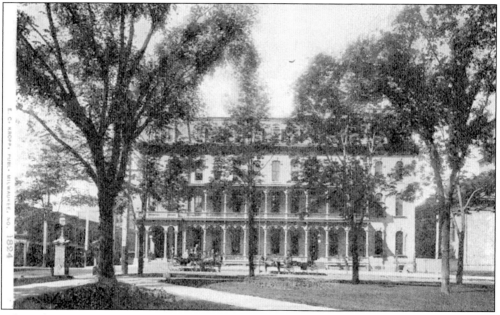

When the 118-room Park Hotel opened on August, 19, 1871, it offered the very finest in service, furnishings, and accommodations in its rooms, suites, parlors, ballroom, and dining room, as well as the first full indoor plumbing on the square—for $3 a day, including room and board. It was immediately popular with legislators and lobbyists, in part because it also served as the unofficial governor's residence until 1885.

24

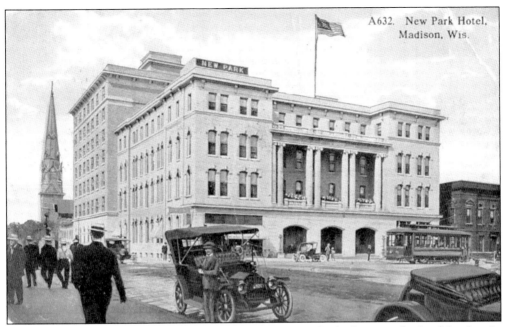

The Park Hotel was remodeled several times to maintain the highest standards of the day. Its Victorian mansard roof was removed in 1911 and replaced with a more modern fourth story. When these two postcards were issued around 1912, the new Park Hotel was helping to make Madison the most popular convention city in Wisconsin.

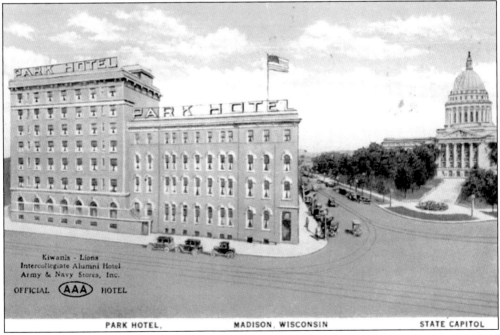

The Park Hotel also catered to well-heeled tourists and other travelers. Madison's tourist trade grew rapidly in the early 20th century, adding fuel to a long-standing debate about whether the city should be developed and promoted principally as a tourist destination, a government center, a university center, or a manufacturing center.

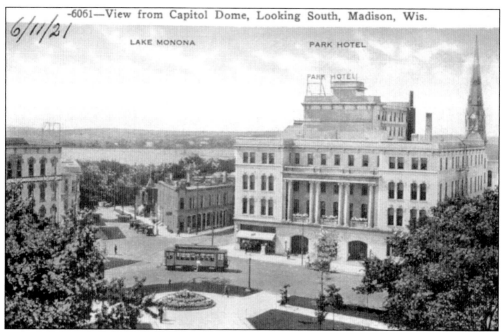

-6061—View from Capitol Dome, Looking South, Madison, Wis.

LAKE MONONA

PARK HOTEL

The A. O. Fox business block is at the left side of this view down South Hamilton Street. It was torn down in 1964 for the Anchor Savings and Loan building. The entire Park Hotel was replaced in 1961 by the all-new 180-room Park Motor Inn (now the Inn on the Park), still one of Madison's premier hotels.

West Washington Avenue from Capitol Park, Madison, Wis.

West Washington Avenue did not open until 1854, the year the Milwaukee and Mississippi Railroad (later the Milwaukee Road) was granted land for a depot there. Grace Episcopal Church at 1 South Carroll Street was one of several churches built on the square and the only one remaining. Beyond it is the Congregational church, dedicated in 1874 and demolished in 1930.

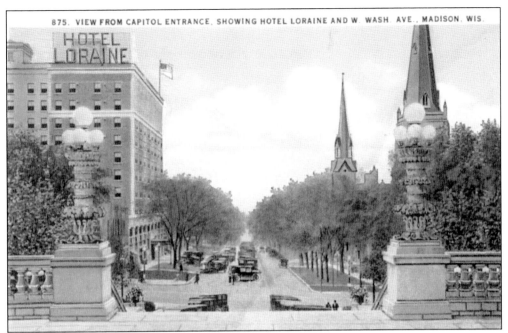

875. VIEW FROM CAPITOL ENTRANCE, SHOWING HOTEL LORAINE AND W. WASH. AVE., MADISON, WIS.

The Hotel Lorraine, at left and below, was already under construction in 1921 when the legislature passed a 90-foot height limit on buildings around the square. A decade earlier, anti-skyscraper forces had tried to get a height limit enacted to protect the skyline around the capitol. The attorney general had declared their bill unconstitutional.

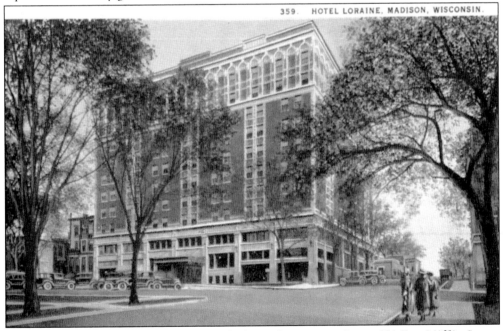

359. HOTEL LORAINE, MADISON, WISCONSIN.

In 1929, the builders of the Belmont Hotel, also under construction at 101 East Mifflin Street, took the new height limit law to the state supreme court. The court ruled in favor of the height limit but allowed construction of the two hotels to continue. Both topped out at around 120 feet.

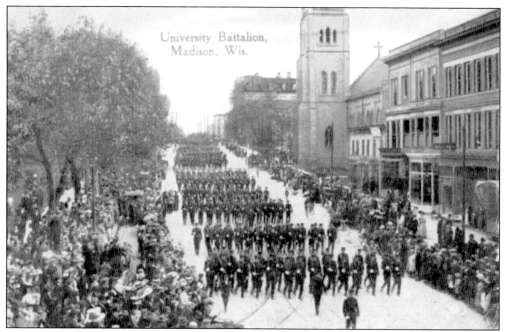

The university battalion marches down South Carroll Street, probably on the Fourth of July sometime in the first decade of the 20th century. Military units, marching bands, labor unions, fraternal societies, student protestors, Masonic orders and other civic organizations, and the Ku Klux Klan have all paraded around the square.

In 1911, Madison developer Leonard C. Gay announced his plan to build the city's first skyscraper at 16 North Carroll Street. Local forces fought the planned encroachment on the skyline without success. The eight-story Gay Building opened to widespread criticism in 1915, despite plush interiors and the city's first Otis High-Speed Elevators. It was renamed the Churchill Building in the 1970s.

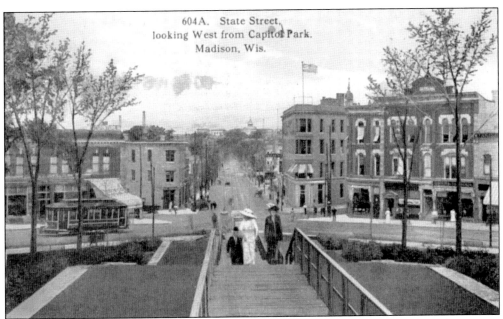

A temporary boardwalk connects the new capitol to State Street in this view from about 1910. The three-story sandstone building at left is the oldest surviving commercial structure on the square, erected by Willet Main in 1855 and 1856. The smokestack above the Main building is at the Hausmann Brewery at State and Gorham Streets. In the distance are the University of Wisconsin's South Hall and Main (later Bascom) Hall.

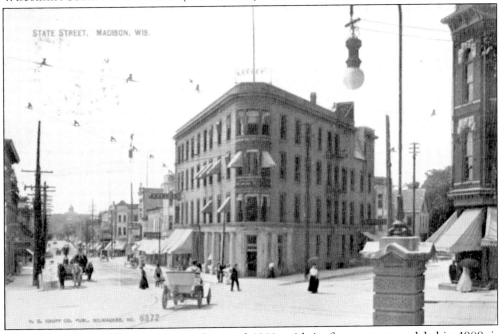

The Wisconsin Building, constructed around 1901, with its first story remodeled in 1908, is seen here around 1910 at the corner of State and North Carroll Streets. Notice the trolley wires and the utility poles lining the street. John Nolen's 1910 report *Madison: A Model City* described State Street as "shabby."

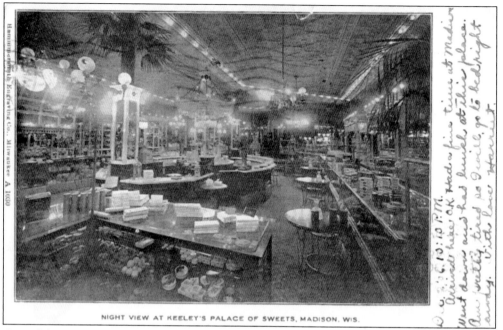

NIGHT VIEW AT KEELEY'S PALACE OF SWEETS, MADISON, WIS.

One of the tenants on the first floor of the Wisconsin Building at 102 State Street was Keeley's Palace of Sweets. Collyer's Drug Store occupied most of the building. Other tenants included osteopathic physician Dr. S. J. Fryette and photographer F. W. Curtiss. This was later the home of the Commercial State Bank.

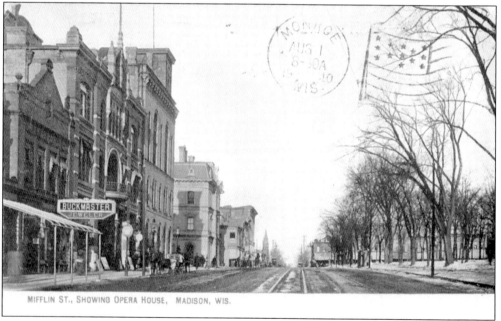

MIFFLIN ST., SHOWING OPERA HOUSE, MADISON, WIS.

City hall, the tallest building in this view, dominated the first block of West Mifflin Street for many years after its construction in 1857 and 1858. Most of the block to its west was a lumberyard or vacant land until local industrialist Morris E. Fuller and his son Edward bought the parcel next to city hall and built the Fuller Opera House, opened in April 1890.

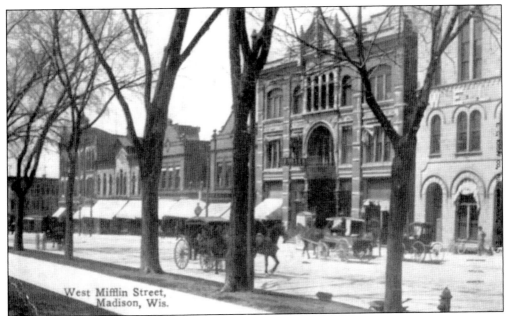

West Mifflin Street,
Madison, Wis.

Fuller Opera House was Madison's first great theater. During its first decade, there were two or three performances every week during the theater season. John Philip Sousa and Sarah Bernhardt were among the performers featured there. However, it was not a financial success, and in 1921, it was remodeled and reopened as the Parkway movie theater. It was torn down in 1952 for a Woolworth's store.

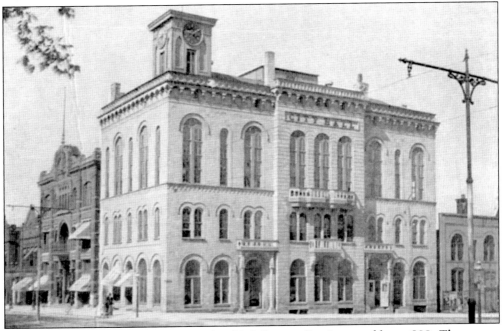

City hall opened in February 1858. The third-floor auditorium could seat 900. There were offices and two jail cells on the second floor. The ground floor and basement were intended for shops, one of which was a saloon until 1873. Two fire engines were stored in the building until 1874, and the city library opened there in 1875.

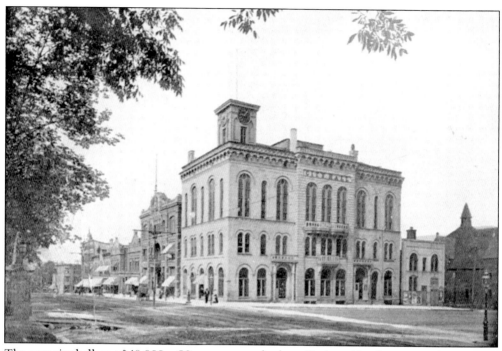

The new city hall cost $40,000—80 percent over budget. Designed by the same architects who designed the second capitol, S. H. Donnell and August Kutzbock, the sandstone city hall was patterned after the Palazzo Vecchio in Florence, Italy. The building was demolished in 1952 and replaced by a two-story Woolworth's store.

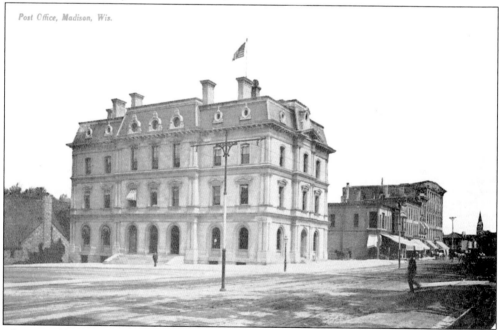

The post office was built in 1872 on the corner of Mifflin Street and Wisconsin Avenue. On this same site in the spring of 1837, Michael St. Cyr built the first house in what would become the city of Madison—a log cabin built for John Catlin, Madison's first postmaster.

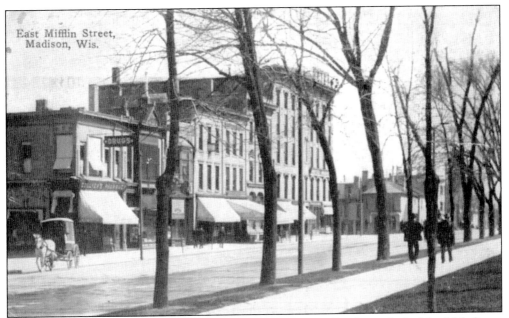

The tallest building in this view of the first block of East Mifflin Street is the Hotel Madison, constructed in 1855. On the far corner at North Hamilton Street is Mathias Hoven's butcher shop. Hoven emigrated from Germany and opened this shop in 1878 and another on State Street a few years later. He served on the city council and won three terms as mayor in 1897, 1899, and 1900.

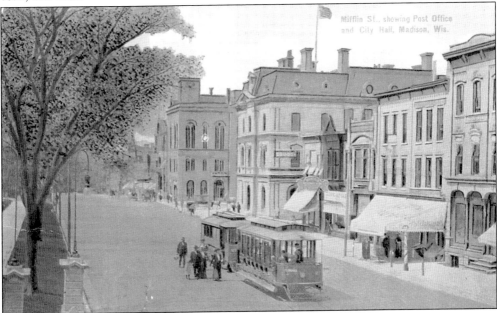

This view looks west down Mifflin Street from Pinckney Street. Mule-car service began in 1884 on a two-mile line across the isthmus. It was never profitable or popular. Electric trolley service began in 1892 on a 5.5-mile line with great fanfare and celebration. The line doubled in length by 1900, opening new suburbs to the east and west and reaching from Forest Hills Cemetery to the Oscar Mayer plant.

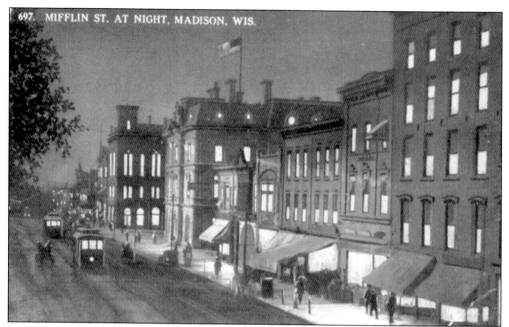

In this hand-tinted "night" view of Mifflin Street, city hall and the post office/courthouse flank Wisconsin Avenue, and the Hotel Madison is at the far right. Coal-gas lights came to Madison in 1855 after the Madison Gas Light and Coke Company was granted an exclusive franchise by the city. Within a few years, most of the city's streets and many of its homes were lit with gas.

The Bacon Commercial College, the precursor of the Madison Business College, opened in January 1856 in the newly built Bacon Block (1855) on the northwest corner of East Mifflin and North Pinckney Streets. The building was remodeled in 1900 to become the Hotel Madison. When the hotel was torn down in 1965, it was the oldest building on the square.

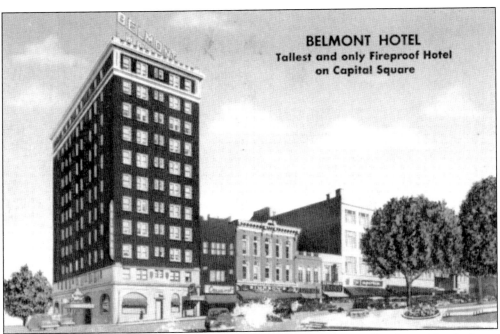

BELMONT HOTEL
Tallest and only Fireproof Hotel
on Capital Square

The Piper brothers had already begun construction of their 115-foot-tall Belmont Hotel, above, on East Mifflin at North Pinckney Street when the legislature enacted a 90-foot height limit on buildings on the square in 1921. The Pipers challenged the law and the supreme court upheld it but allowed completion of their hotel.

Opened in 1924, the Belmont Hotel offered $2 rooms to traveling businessmen, compared to the pricier and more elegant rooms at the Hotel Lorraine or the Park Hotel. The Belmont was built on the site of one of Madison's earliest churches, the Methodist Episcopal church, dedicated in September 1853. The former Belmont Hotel is now home to the YWCA.

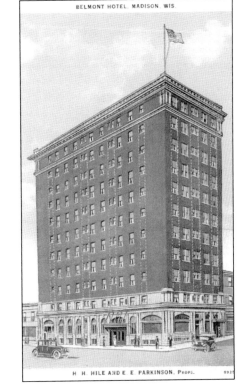

BELMONT HOTEL, MADISON, WIS.

H. H. HILE AND E. E. PARKINSON, Props.

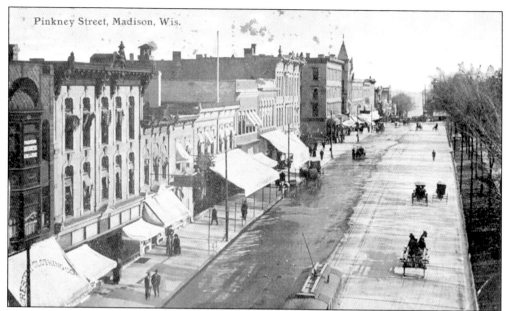

Pinkney Street, Madison, Wis.

From left to right on North Pinckney Street are the Winterbotham building (1897), the Ellsworth Block (Ellsworth Brothers Grocery, 1871), the Maeder building (1871), and the Grube building (1880). Two doors south is the Hobbins Block (1906), and next to it is the Olsen and Veerhusen building (1899). All are still in use. At 1 North Pinckney is the Mason-Baker Block (1871) built after the village-era American Hotel burned in 1868.

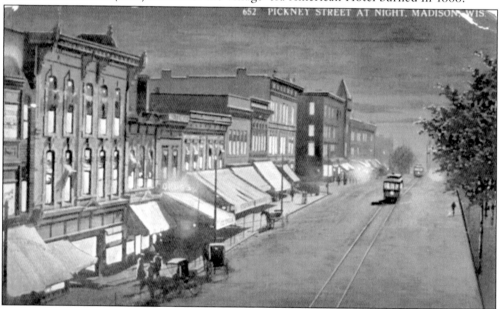

652 PICKNEY STREET AT NIGHT, MADISON, WIS.

Electric lights came to Madison in 1888 after the city council granted a nonexclusive franchise to the Madison Electric Light Company. The franchise wars continued until 1896 when a New York–based utility syndicate bought up Madison's squabbling utility companies and formed Madison Gas and Electric Company. The syndicate promoted electric lighting and gas cooking and subsidized the creation of the Madison Cooking School, which, of course, used gas stoves.

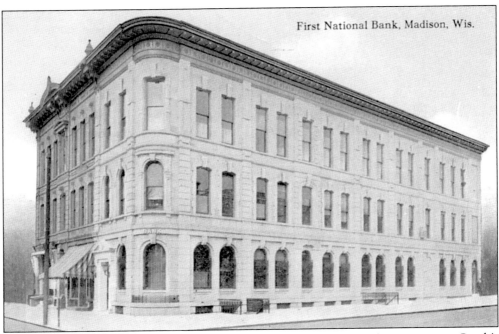

First National Bank, Madison, Wis.

The Mason-Baker Block was built in 1871 on a historic piece of Madison property. On this corner, James Morrison and A. A. Bird opened their American Hotel in the fall of 1838. Wisconsin's territorial legislature met there in November 1838, while the first capitol was under construction. Expanded in 1851, the wood-framed American Hotel burned in 1868.

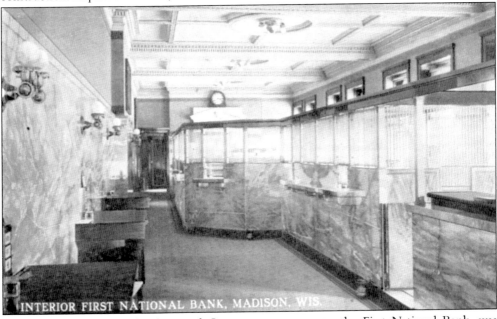

INTERIOR FIRST NATIONAL BANK, MADISON, WIS.

In the 1850s, James Richardson and Company, precursor to the First National Bank, was quartered in the Bruen Block at 1 South Pinckney Street. The deep depression of 1892 through 1894 threatened many Madison banks, although most weathered the storm. Worried depositors lined up in June 1893 to withdraw their funds. Late at night, the First National Bank shipped in $175,000 in gold to avoid defaulting on its deposits.

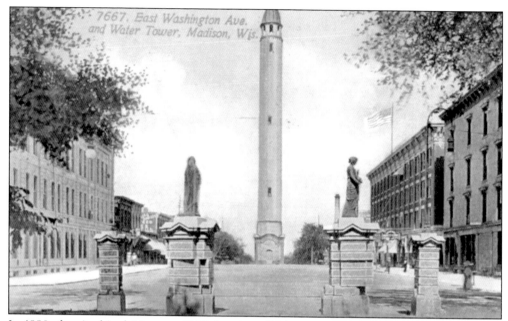

In 1880, the city hired 26-year-old University of Wisconsin student Magnus Swenson to test the city's more than 1,000 backyard wells. Nearly all were contaminated with sewage from nearby outhouses. Two years later, the legislature authorized the city to own and operate its own water utility. Service began in December 1882 with water from artesian wells. This water tower stood on East Washington Avenue from 1889 until 1921.

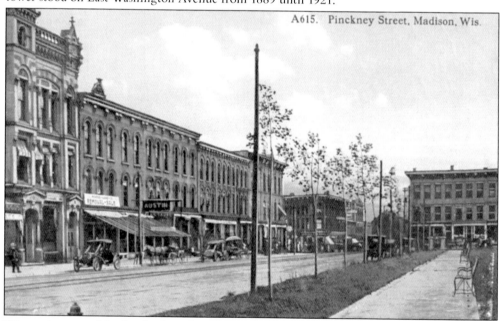

Wisconsin enacted its first banking law in 1852. Within four years, seven new Madison banks appeared. Milwaukee bankers Samuel Marshall and Charles Ilsley founded one in 1853 in the turreted building at far left. Also in this block, John Suhr founded the German American Bank in 1887. In June 1918, near the end of World War I, the German American Bank changed its name to American Exchange Bank.

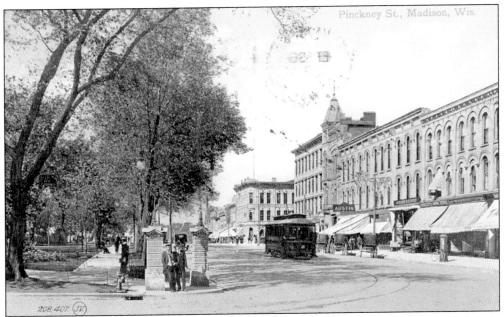

A Brill electric trolley car coasts past Moseley's Book Store (third awning from the right). At 1 North Pinckney is the 1871 Mason-Baker Block, now home to the American Exchange Bank. Across East Washington Avenue at 1 South Pinckney Street is the village-era Bruen (later Brown) Block, replaced in 1920 by the First Central building, a joint effort by three Madison banks.

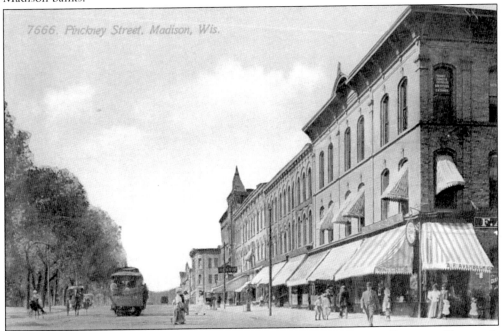

The third-story corner window in the 1875 Tenney Block advertises, "Tenney, Tenney, & Reynolds, Law Offices." This corner was the site of the Worser saloon and gambling den in the village days and later the American Hotel and United States Hotel Block. The three-story Tenney Block was replaced in 1931 by the Tenney Building.

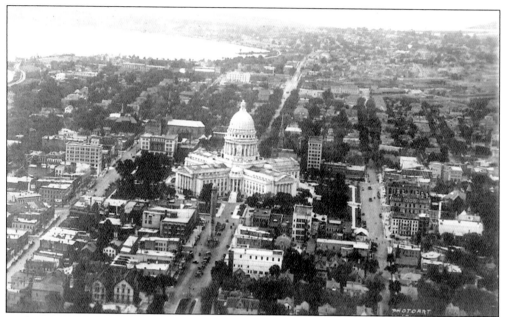

In this aerial view from about 1917, the Gay (later Churchill) Building is still the tallest on the square, the old city hall (1858) and post office (1871) still flank Wisconsin Avenue, and the water tower still stands on East Washington Avenue, although the horse market and farmer's market that once flourished at its base has been moved to the 1910 city market building on North Blount Street.

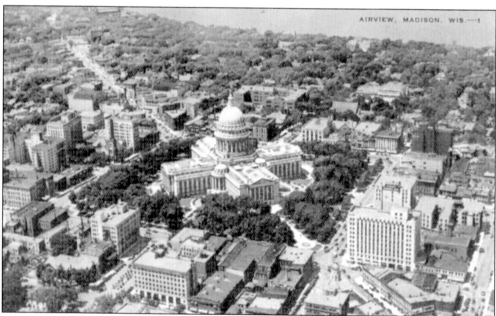

In this 1930s view up King Street, the Tenney Building (1921), First Central building (1921), and Belmont Hotel (1923) line Pinckney Street. Harry Manchester's new store (1930) is on Wisconsin Avenue, and the new post office (1929) is partly visible on Monona Avenue. The Orpheum (1927) and Capitol (1928) Theatres flank State Street, and the Memorial Union (1928) and campus YMCA (1906) are just visible beyond the Red Gym (1894).

Three

DOWNTOWN

In James Doty's original plat of Madison, the capitol park was the only public space. Doty ignored most of the opportunities and challenges the lakes presented for designing a new community. He simply imposed a classic grid pattern of streets onto the isthmus, placing the capitol park midway between the two largest lakes.

A more experienced and sensible planner might have laid out the streets that radiated from the capitol square as grand promenades, with each ending in lakeside parks or in a single public park that stretched along the shore of each lake.

Instead Doty's plat gave over the radial streets and the lakeshores to private property. North and South Wisconsin Streets (later Wisconsin Street and Monona Avenue) featured stately mansions near the lakes. On Doty's plat, King Street, the town's first developed thoroughfare, and North Hamilton Street terminate at the mouths of an industrial canal just three blocks east of the capitol.

Doty's first plat included a railroad right-of-way coming directly onto the capitol square, up East Washington Avenue, and through the heart of the isthmus. A later proposal would have brought railroad tracks from the west up State Street and out Johnson Street to the east. Wiser heads prevailed, placing the tracks along the shore of Lake Monona below the bluffs. Even then, the railroad yards on West Washington Avenue, less than a mile from the capitol square, would frustrate development of the near west side well into the 20th century.

Early in Madison's history, the South Wisconsin (later Monona) Avenue entrance came to be seen as the capitol park's front door. By the early 20th century, visionaries like John Nolen were calling for a stately "capitol plaza" on the avenue, lined with government buildings and ending in a suitably grand public space on the lakeshore. Architect Frank Lloyd Wright submitted eight separate designs for Monona Terrace between 1938 and his death in 1959. His and Nolen's visions were finally realized (at least in part) with the opening of the Monona Terrace Community and Convention Center in July 1997.

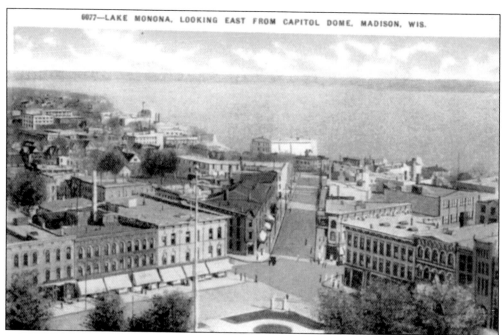

6077—LAKE MONONA, LOOKING EAST FROM CAPITOL DOME, MADISON, WIS.

King Street, seen here about 1900, was the city's first improved street and its first business district. It also illustrates one of James Doty's glaring mistakes in laying out Madison's first plat. The "grand view" from the capitol ends not in a lakefront vista but in an industrial muddle. Doty's proposed industrial canal would have ended near the large icehouse at center.

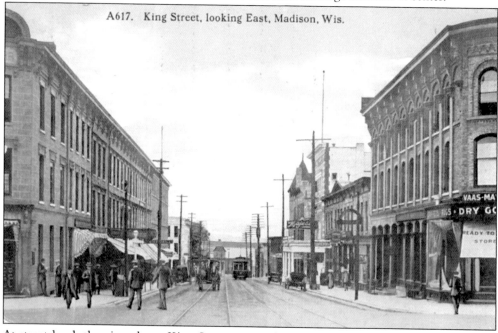

A617. King Street, looking East, Madison, Wis.

At street level, the view down King Street was perhaps more impressive, with solid business blocks in a bustling commercial district. On the right is Simeon Mills's business block (1852–1855). The turreted building on the right at King and Doty Streets is the 1889 Christian Dick Block. Down the street on the left is Breckheimer's Brewery.

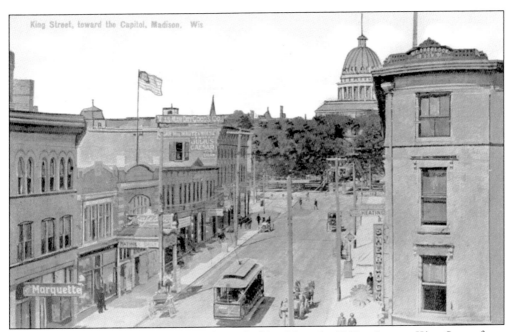

The trolley line has not yet been double tracked in this early-1900s view up King Street from Doty Street. King Street is graded and oiled but not yet paved, and the second capitol still stands on the square (it burned in February 1904). Many of the buildings on the left side of the street have survived.

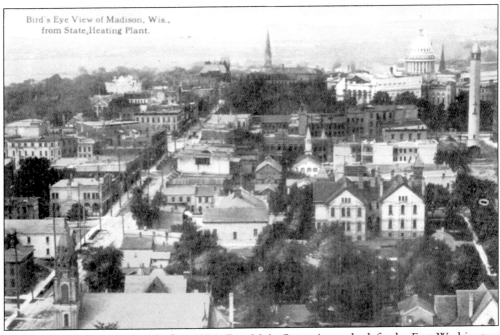

In this view from sometime before 1904, East Main Street is on the left, the East Washington Avenue water tower is at upper right, and the second capitol dominates the skyline. Wooden sidewalks line the unpaved Main Street. St. Patrick's Church is at lower left. The hulk on West Main Street to the left of St. Raphael's Church spire is the 1886 Dane County Courthouse.

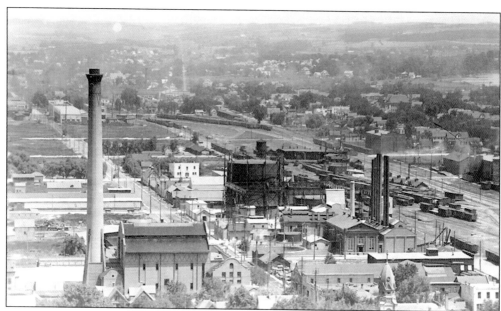

This view looks east down Main Street from the capitol dome. From left to right, the capitol heating plant, the gas works, the electric-generating station, and the Chicago and Northwestern Railroad yard dominate the view. The spire of St. Patrick's Church is just visible at lower right. Ingersoll Street runs across the middle distance.

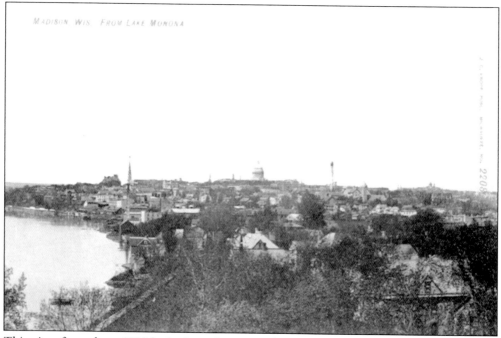

This view from about 1900 looks from the east end of Lake Monona toward the capitol from near Orton Park. It might have been taken from Mayor Leonard Farwell's former mansion, which was built in 1855, converted to a soldiers' hospital and soldiers' orphans' home in the 1860s, and made into a school in 1876. The tall smokestack to the right of the capitol is the heating plant seen at the top of this page.

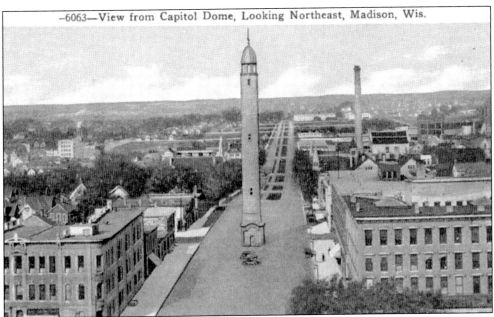

-6063—View from Capitol Dome, Looking Northeast, Madison, Wis.

This view down East Washington Street clearly shows the cattail marsh at the foot of the hill that impeded east-side development for so long. The village-era Bruen Block (1854) and the 1871 Park Savings Bank (now American Exchange Bank) flank the avenue. The Water Tower Horse Market has moved (in 1910) to the new city market on Blount and Mifflin Streets. The water tower stood until 1921.

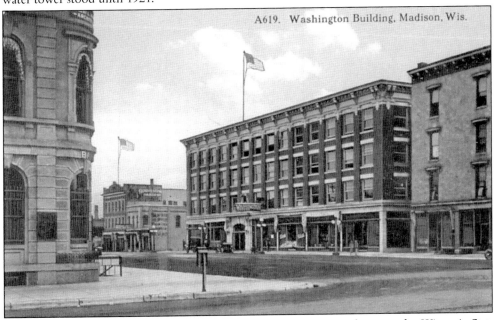

A619. Washington Building, Madison, Wis.

The Washington Building at 119 East Washington Avenue was once home to the *Wisconsin State Journal*. It replaced the village-era Journal Block. Bruen's Block is on the right, and Park Savings Bank (now American Exchange Bank) is on the left. The north wing of the bank building on Pinckney Street (top of the page) was destroyed by fire. The south wing along East Washington Avenue survives (see also page 37).

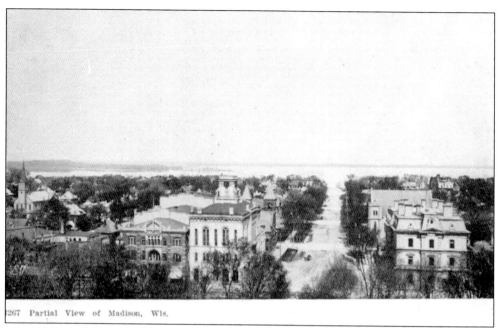

267 Partial View of Madison, Wis.

The 1858 city hall and 1872 post office flank Wisconsin Avenue in this early view. The Fuller Opera House (1890) is next to city hall. Behind the post office is the 1871 Unitarian church across from the 1892 Christ Presbyterian Church. Barely visible beyond the Presbyterian church is the first city high school, which opened in 1873 on Wisconsin and Gorham Street.

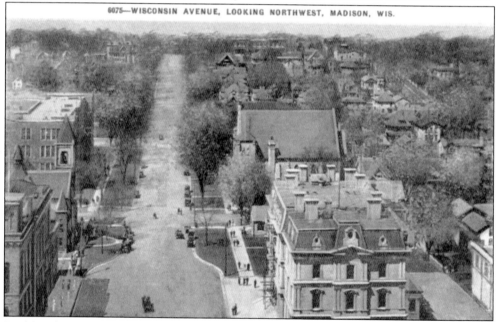

6075—WISCONSIN AVENUE, LOOKING NORTHWEST, MADISON, WIS.

Looking down Wisconsin Avenue a few years later, this view clearly shows the new high school that opened in 1908 on Gorham Street. The 19th Amendment allowed women to vote in 1904 in municipal elections involving school matters. In a referendum to fund the new high school, most men voted no, but more women voted yes, and the referendum passed by 300 votes out of 4,000.

46

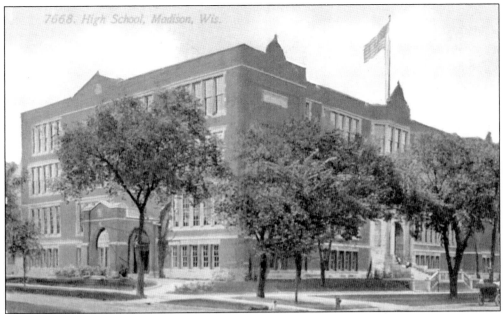

By 1900, the 1871 high school was overcrowded and outdated, despite an 1887 addition. The new $250,000 school, seen here, was full to capacity—nearly 600 students—when it opened in September 1908. When East High School was opened in 1922, this became Central High School. When it was demolished in 1986 to make way for a vocational school, its Oxfordian-style Johnson Street entrance arch was retained for the new building.

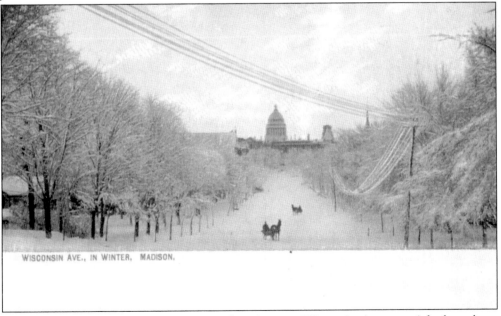

From the looks of the telephone wires, this view up Wisconsin Avenue might have been photographed after an ice storm sometime before 1904. For all but a handful of years between 1855 and 1905, Lake Mendota was frozen over each winter for nearly four months. In the current century, the average has been about two and a half months. The record—161 days—was set in the winter of 1880–1881.

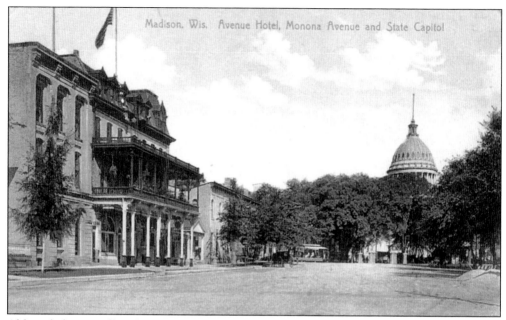

Although the capitol's architects considered Monona Avenue (Martin Luther King Jr. Boulevard) to be its front entrance, it never developed into the grand mall and esplanade that visionaries hoped for. This view before 1904 shows, from left to right, the GAR (Grand Army of the Republic) hall, the Avenue Hotel, and the Western Union office. The street is graded but not paved; note the gravel piles at far right.

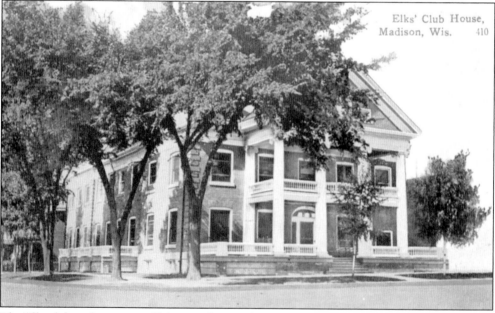

The Elks club at the corner of Monona Avenue (Martin Luther King Jr. Boulevard) stood next to the GAR hall (see above). On occasion, city aldermen would "hide out" here during council meetings to avoid voting on controversial issues. Some sources say the Elks club was built in 1905, but the postcard on the front cover shows the Elks club and the second capitol, which burned in 1904.

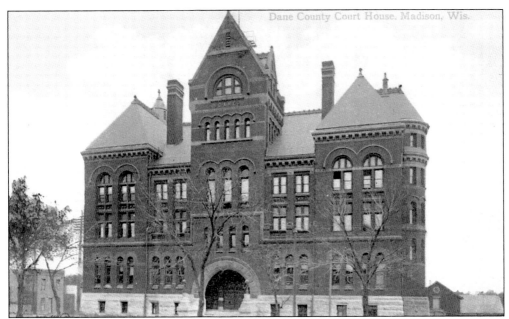

The first Dane County Courthouse was a three-story Greek Revival stone-and-wood structure built in 1851 in the first block of South Carroll Street. The Park Hotel opened next door in 1871. It was in the courthouse that Robert M. LaFollette started his career in public service, becoming a district attorney. The new courthouse, seen here, opened in November 1883, and the old one closed six months later.

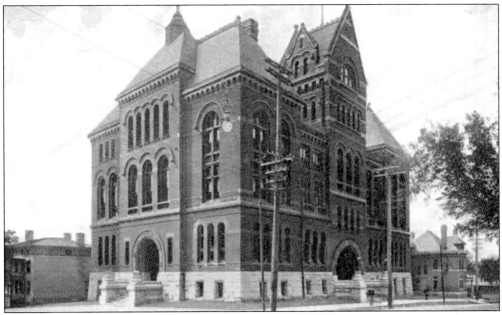

The Romanesque courthouse on West Main Street at Fairchild Street was designed by architect Henry Koch, who also designed the University of Wisconsin's present Science Hall (1888). This courthouse served Dane County until 1956, when the present city-county building was opened on Monona Avenue (Martin Luther King Jr. Boulevard) and this building was demolished to make way for a parking lot.

West Washington Avenue, seen here before 1904, was not opened as a street until 1854, a year before the cornerstone was laid for Grace Episcopal Church. West of Bedford Street, it remained a rough track for 50 years, intersected by the Milwaukee Road railroad yards and ending in the cattail marsh near Regent Street.

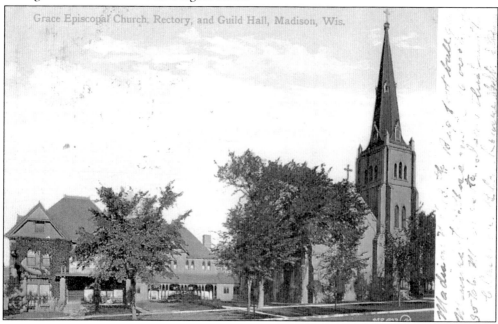

Members of Grace Episcopal Church held their first service in 1850 and built the present building from sandstone between 1855 and 1858. The church windows include one by Louis Tiffany and Company. The Cornelia Vilas Guild Hall, to the left in this view from West Washington Avenue, was donated by William F. Vilas, benefactor of Vilas Park, in memory of his daughter.

Governors, railroad presidents, banking moguls, and millionaire developers built houses on Mansion Hill, the lakefront neighborhood bounded by Wisconsin Avenue, East Johnson Street, and Blair Street. Some of the elegance of Mansion Hill rubbed off on the Gorham-Gilman-Langdon neighborhood, seen here, just west of Wisconsin Avenue. Many fine homes have survived here.

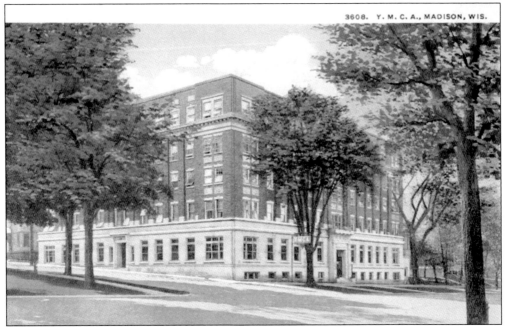

Madison's first YMCA was on the University of Wisconsin campus next to the Red Gym. A new YMCA opened in March 1919 on East Washington Avenue across Fairchild Street from the Hotel Lorraine. It included club rooms, classrooms, a reading room, a swimming pool, a bowling alley, a cafeteria, and 144 reasonably priced sleeping rooms. It was torn down in 1982.

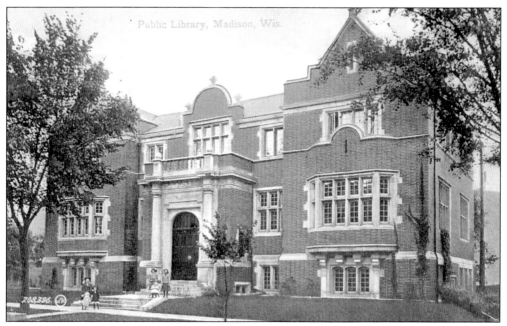

Madison Free Library opened in 1875, with 3,000 donated books housed in city hall. In 1906, the library's 17,000 books were moved into the building seen here at 206 North Carroll Street, donated by steel magnate Andrew Carnegie. The library moved to a new building on Mifflin Street in 1965, and this building was demolished.

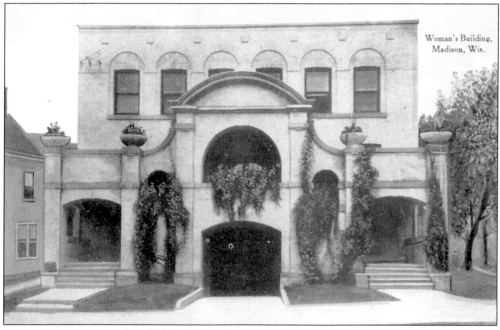

Begun in 1893 as a cultural club, the Madison Women's Club became a powerful force for change. Members crusaded for children's health, clean milk, school libraries, kindergartens, school lunch programs, and other Progressive reforms. In 1906, they built their headquarters at 240 West Gilman Street, seen here. The building survives in private hands.

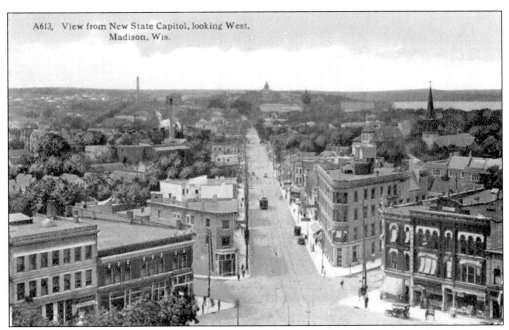

A613. View from New State Capitol, looking West, Madison, Wis.

As the University of Wisconsin grew in size and stature, State Street, seen here, began to eclipse King Street as the premier downtown business street. In the early 1900s, Madison parks superintendent John Nolen advocated widening State Street to 150 to 200 feet and lining it with massive ornamental buildings, to make it "the city's main thoroughfare."

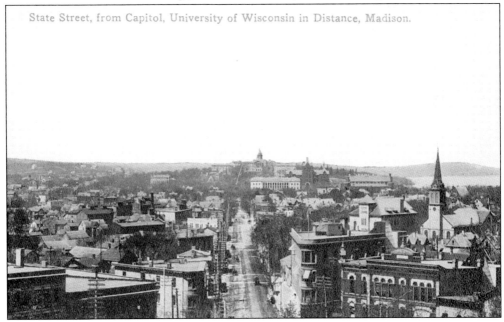

State Street, from Capitol, University of Wisconsin in Distance, Madison.

This view down State Street illustrates more starkly the conditions that led Nolen to describe the street as "narrow," "crooked," and "shabby." But the monumental avenue that Nolen envisioned would have been all out of scale with the existing street and its surroundings. He did convince the city to bury the power lines but his far-too-grand vision for State Street went unrealized.

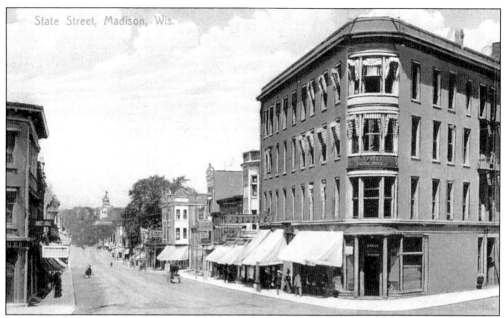

State Street was called West King Street until 1855. In this view from North Carroll Street around 1910, the power lines have been buried. The sandstone Willet Main building (1854–1855) stands at far left. Tenants in the 1901 Wisconsin Building at right include Collyer's Drugstore, Keeley's Palace of Sweets, photographer F. W. Curtiss, and osteopathic physician Dr. S. J. Fryette.

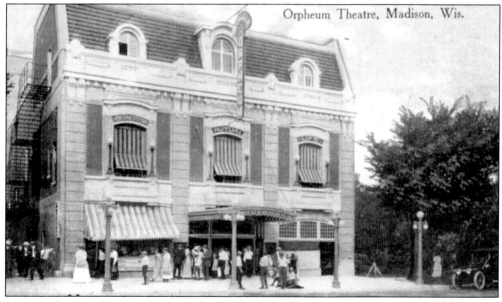

The Orpheum Theatre at 216 State Street opened on March 21, 1927, with three standing-room-only performances of vaudeville acts and moving pictures. It was the first of three grand movie palaces—Orpheum, Capitol, and Eastwood—to open in as many years. The Orpheum's magnificent lobby has been largely preserved. The Capitol Theatre is now part of the Overture Center. The Eastwood, with its Spanish interior gutted in 1967, survives as the Barrymore Theatre.

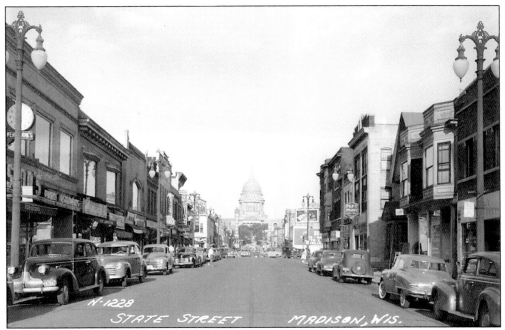

In this early-1950s view from the 400 block of State Street, the trolleys are gone (since 1935), as are the Hausmann Brewery at Gorham Street and the Mautz Brewery at Gilman. The Hausmann Brewery, long a favorite of University of Wisconsin students and a nuisance to its administration, burned in 1923 and was replaced by a gasoline station and car dealership.

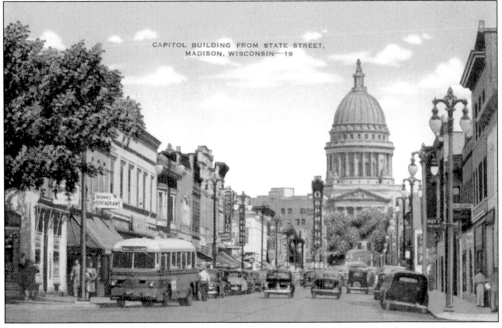

In 1928, a new ordinance banned left turns off this stretch of State Street from Gorham Street to the square to ease traffic snarls. Downtown merchants howled in protest, and the ordinance was repealed. Two years later, the ban was revived—at the request of the State Street merchants' association. Many of the 19th-century buildings in these views survive.

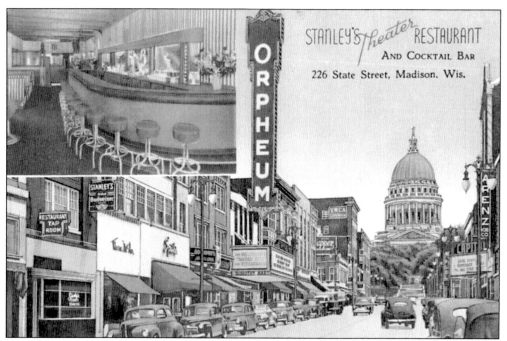

In 1929, Frank Kessenich moved his upscale women's clothing store from the square to a $200,000 showplace at State and Fairchild Streets. Across State Street, Hills Department Store catered to less-expensive tastes. Together they sparked a commercial revival on the street. The Orpheum's 63-foot-high sign bent a few noses when it was unveiled, but the city council thought it was sophisticated and changed the sign ordinance.

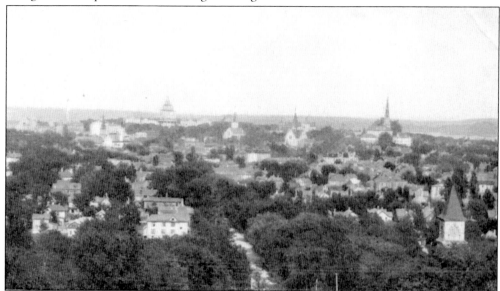

In 1934, an anonymous letter to the *Milwaukee Sentinel* compared State Street to a "spinal cord," connecting the "head" of government with the "heart" of the University of Wisconsin. Strained metaphors aside, State Street and downtown Madison have always catered to and been influenced by both institutions although not always for the best. In 1922, the city hired two dozen extra policemen to deal with Halloween hooliganism.

Four

AROUND THE TOWN

James Doty's first plat of Madison, recorded in 1836, included an industrial canal lined with mills and factories three blocks east of the capitol. King Street, running east from the capitol, ended at the lakeshore in a jumble of mills, factories, and a brewery.

On North and South Wisconsin Avenue (Wisconsin Avenue and Monona Avenue), fine mansions lined the lakeshore and adjacent streets, with business blocks, hotels, and government buildings nearer the capitol.

The University Addition, platted in 1850, set the precedent for the west side. The first university building, South Hall, opened on the college hill in 1855, and the factories at the foot of Lake Street soon gave way to faculty homes.

On the 1854 plat map of Madison, the east–west "factory/faculty" pattern is already evident. That divide was solidified with the opening on East Washington Avenue of the Johnson and Fuller Manufacturing Company in 1882 and the Gisholt Machine Company in 1885. Johnson and Fuller was the city's largest employer, and east-side working-class neighborhoods grew much faster than the rest of the city in the last decades of the 19th century. On the west side, University of Wisconsin faculty and white-collar professionals built their homes in the new suburbs of University Heights, Wingra Park, Oakland Heights, and Nakoma.

One glaring exception to the east–west pattern was the railroads. The expansive Milwaukee Road yards that grew up a mile west of the capitol in the 1850s complicated the development of the near-west side for more than a century.

When John Nolen characterized Madison's development as "accidental" and "haphazard" in 1908, he could have been describing 99 percent of American cities. Like most cities, Madison had no zoning code. Its railroads were "disruptive" and "dangerous," its lakeshores were "wasted," and its waters were polluted. The period of 1900 to 1920 brought profound and lasting changes to the city—parks and playgrounds, water and sewer systems, hospitals and broad public-health initiatives, and an entirely new concept called urban planning.

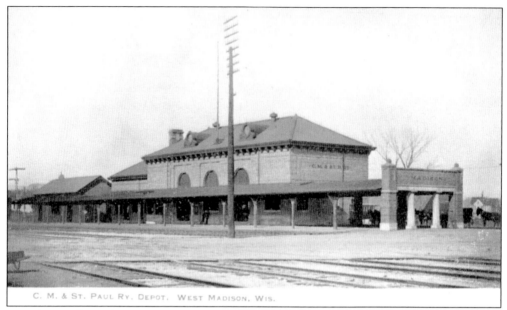

C. M. & St. Paul Ry. Depot, West Madison, Wis.

Two thousand people greeted the first train into Madison in May 1854. The Milwaukee and Prairie du Chien Railway (Milwaukee Road) built a causeway across Monona Bay and a depot on West Washington Avenue. There was not a single building between the depot and the square, and the new train station was in deep woods. This depot at 644 West Washington Avenue was built in 1903.

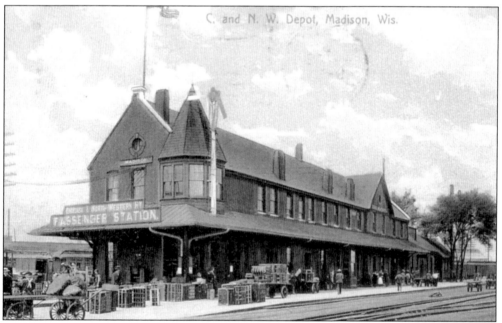

The Chicago and Northwestern Railroad (CNW) reached Madison in 1864, crossing Monona Bay and the Milwaukee Road tracks and creating the nation's only mid-lake railroad crossing. The CNW built the depot seen here at Blair and East Wilson Streets in 1871. Its monopoly lost, the Milwaukee Road built a second depot at 501 East Wilson Street to upstage the CNW. The Wilson Street yards are visible on page 44.

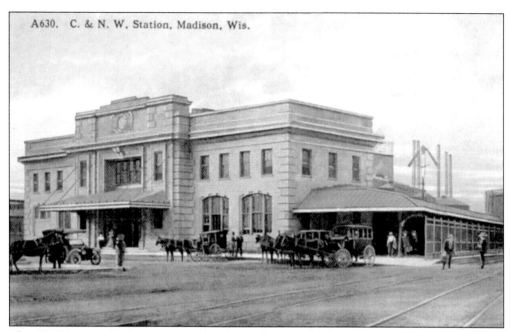

The CNW opened this new depot in 1910 at 219 South Blair Street on the site of its 1871 station. The Wisconsin Wagon Company factory is just visible beyond the depot at far left. Eventually, 10 railroad lines served Madison—five from CNW, four from Milwaukee Road, and one from Illinois Central Railroad.

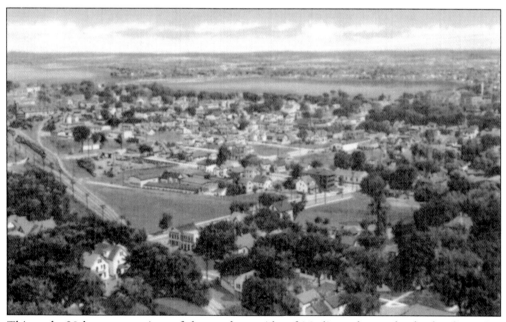

This early-20th-century view of the southeast side of Madison shows clearly the disruptive effect of the railroad right-of-way, slicing through the west side of the city with no commercial benefit, since most of the factories were to the east of the isthmus. West Washington Avenue crosses in the foreground. The large edifice in the distance on the far right is St. Mary's Hospital, opened in 1912.

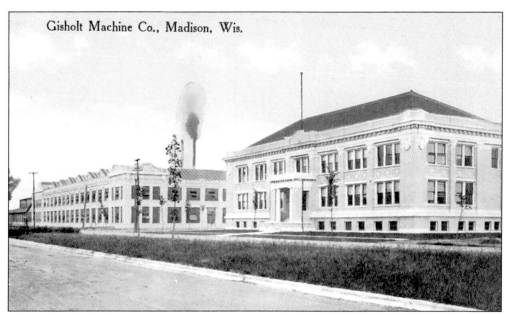

Gisholt Machine Co., Madison, Wis.

The railroads fueled a commercial boom in Madison. Farm produce and manufactured goods flowed out, and raw materials, merchandise, and settlers flowed in. Morris E. Fuller and John Anders Johnson bought out the Madison Plow Company and set up Fuller and Johnson Manufacturing Company in 1880. Two years later, it was Madison's largest employer. Johnson also helped establish the Gisholt Machine Company, seen here, in 1885.

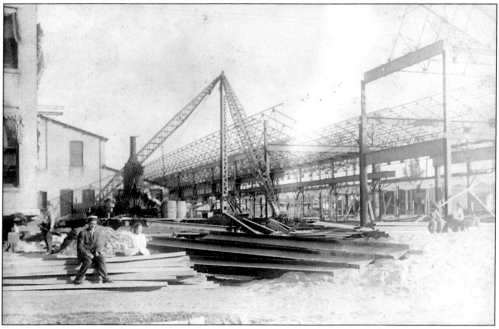

Johnson set up the Gisholt Machine Company to build machine tools for Fuller and Johnson Manufacturing Company. This 1912 postcard shows the Gisholt plant under expansion. The unidentified sender of the card is pictured sitting next to a young girl on a pile of lumber. Behind him and to the right is a steam-powered stiff-leg derrick used in construction.

The Farmers' Cooperative Packing Company was organized in 1914 to break the Chicago beef trust's hold on area farmers. Five thousand farmers bought $600,000 in stock. Rebuffed by the village of Fair Oaks, the co-op built its plant, seen here, next to the new city sewage plant. Slim profits and a workers' strike broke the co-op's bank. Reluctantly, the stockholders put their two-year-old plant up for sale in June 1919.

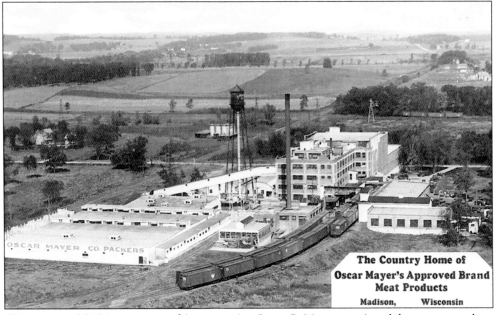

Thirty-year-old Chicago meatpacking executive Oscar G. Mayer convinced the co-op members that he would run the plant independent from the Chicago beef trust. They agreed to sell, and the plant reopened in late November. Mayer kept his word, and by 1920, Madison boasted the fifth-largest meatpacking plant in the nation. The company paid Madison's streetcar company to extend its line to the plant and built 50 affordable homes for workers.

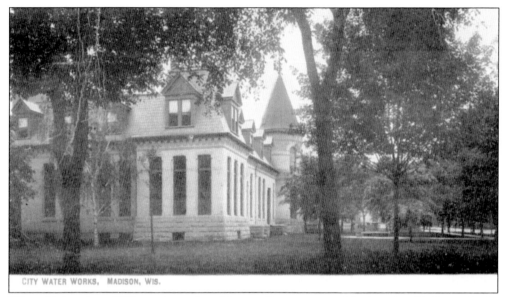

CITY WATER WORKS, MADISON, WIS.

When University of Wisconsin student Magnus Swenson tested backyard wells for purity in poorer neighborhoods in 1880, he found that 90 percent were polluted by nearby outhouses, causing, he concluded, high rates of diphtheria, typhoid fever, and scarlet fevers in those neighborhoods. J. J. Brown, a prominent physician, scoffed at Swenson's analysis and called it fear mongering. But Swenson's scientific data trumped the doctor's tirades, and Madison laid plans for a municipal water system.

Built by a New Jersey water company, the water system began delivering clean, cheap water from deep artesian wells in 1883. Demand eventually taxed the system beyond its limits until water commissioner John Heim ordered meters installed in 1888. Consumption immediately dropped to manageable levels, and the water system became a model copied by cities nationwide. The waterworks shown here and above were built on Gorham Street in 1917.

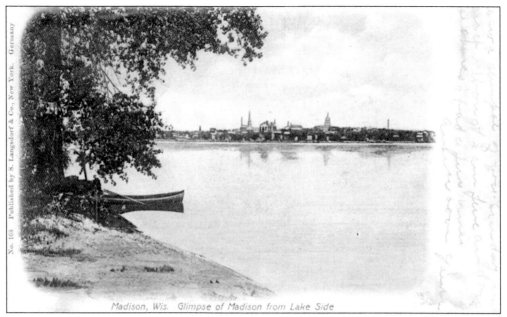

Madison, Wis. Glimpse of Madison from Lake Side

Meanwhile, Madison's sewage system dumped several hundred thousand gallons of untreated sewage into the Yahara River every day, while private outflows dumped an equal amount directly into Lake Monona. Raw sewage piled up on Lake Monona's north shore, seen here from across the water. The city council considered a treatment system in 1885 but dropped it for financial reasons. The city would not fully solve its sewage problems until 1952.

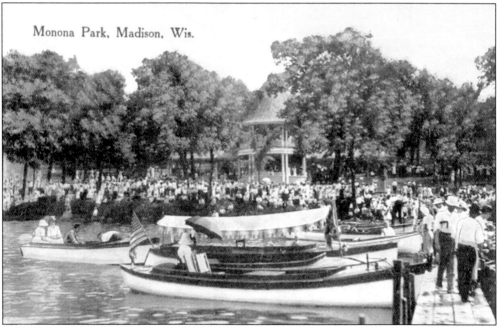

Monona Park, Madison, Wis.

Brittingham Beach never opened in 1916, thanks to the polluted state of the lake. But tourists and locals alike still frequented Lake Monona's parks and resorts, especially those along the south shore. A large crowd gathers at Monona Park (now Olin-Turville Park) for an Independence Day celebration sometime around 1910.

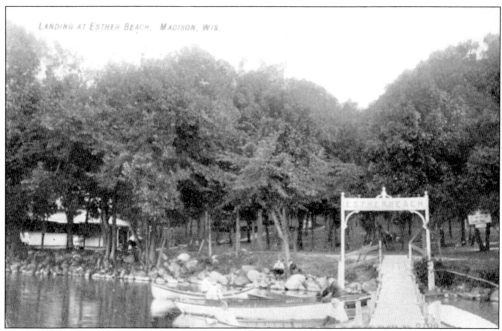

From the 1890s to the 1920s, the city dumped tons of chlorine into Lake Monona to kill bacteria and tons of copper sulfate algaecide to combat algae blooms that made part of Lake Monona and Monona Bay impassible to boats. Above, boaters and fishermen relax at Esther Beach nearer the Yahara River's outlet.

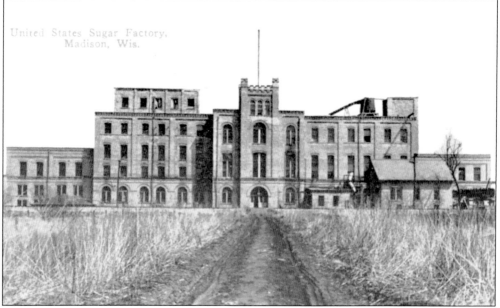

When the United States Sugar Factory opened in the village of Fair Oaks in 1906, it was Madison's largest factory building. The company offered farmers top dollar for beets and high-paying autumn jobs to encourage them to grow sugar beets. At its peak, the plant ran around the clock, seven days a week, producing 50 tons of sugar a day. Cheap foreign sugar put the company into bankruptcy in 1924.

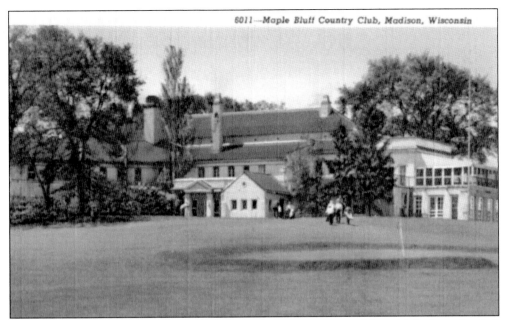

In 1899, several golfers laid out a five-hole course on a pasture rented from Halle Steensland. A year later, they raised $5,000 to buy 58 acres at Maple Bluff and build a clubhouse, completed in 1901, along with an improved five-hole course. Four more holes were added a few years later. A herd of sheep helped keep the fairways smooth. The present clubhouse, seen here, was built in 1922.

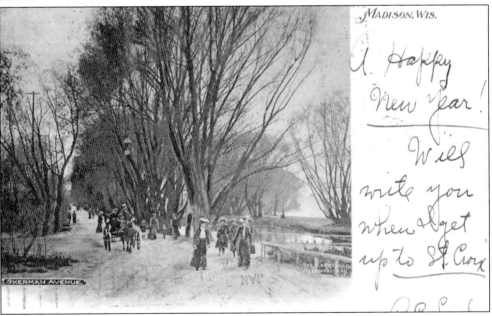

Some golfers reached Maple Bluff Country Club by buggy along Mendota Drive or Sherman Avenue, seen here near the present Tenney Park about 1905. Some golfers arrived on steamboats that made several daily trips to Maple Bluff from the university pier. For a time, the country club owned a 40-foot steamer, the *Putter*, which ran between Carroll Street and a pier near the club. Lake Mendota is visible to the right.

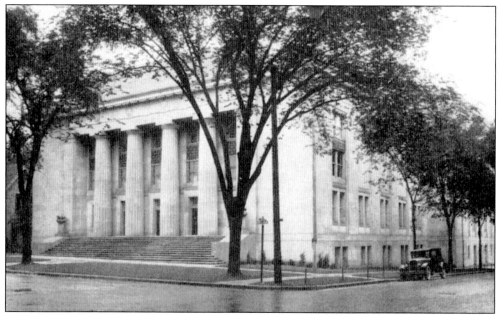

The Masons began erecting a new Masonic temple in 1923 on the site of their old temple on the corner of Wisconsin Avenue and Johnson Street. The *Wisconsin State Journal* called it, "among the most imposing edifices in the city." It housed two lodge rooms, dining rooms, club rooms, and a 1,500-seat auditorium. Its 30-foot tall, 50-ton Bedford stone columns, quarried in Indiana, created a dramatic facade on Wisconsin Avenue.

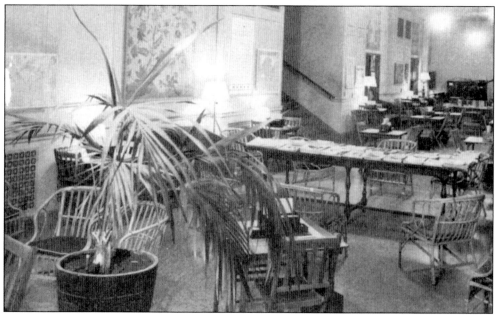

The new temple had to be constructed around the old, so as not to interrupt the schedule of Masonic lodge meetings. When finished, the building housed 11 different bodies. Each of the two lodge rooms, "finished in classical style," included an organ, seating for 250, and "furnishings necessary for the working of degrees." The huge dining room, seen here and on the facing page, could seat 1,000 diners.

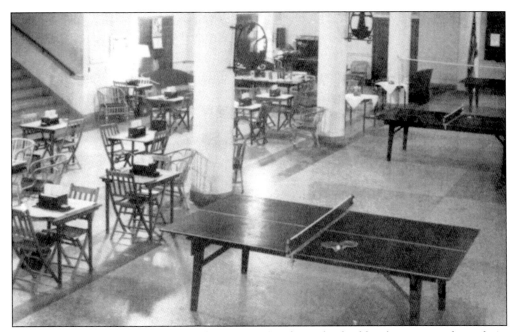

The *Wisconsin State Journal* reported in great detail on the building's progress through its 18 months of construction. Upon its completion in 1925, the journal took its readers through every room in the building, describing it in glowing terms. The kitchen, it said, is "equipped with every modern convenience known to culinary science."

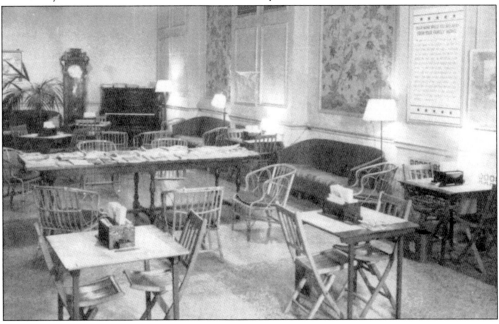

Elsewhere in the building were a reading room, a card room, a large billiards room, a smaller dining room, and other amenities, all glowingly described in detail by the *Wisconsin State Journal*'s reporter. The building cost $500,000. Architect James Law visited Masonic temples all over the country "to get the last word in buildings of this character," the journal said. It is still in use by the Masons.

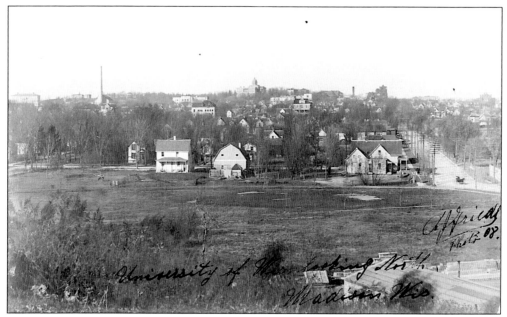

In this view up Park Street from the vicinity of St. Mary's Hospital, the most notable feature is the dome on Bascom Hall at center. The street crossing the foreground is probably Erin Street. When St. Mary's Hospital opened, local physicians complained that it was "inconvenient"—too far from the city. But several locations closer to town were opposed by residents who did not want a hospital in their neighborhoods.

The 1920 census counted 38,378 souls in Madison. Ten years later, the city had grown by 50 percent to 57,815. All those people generated an awful lot of laundry, and there were several companies in Madison dedicated to washing it all. Pictured here about 1929 is the combined Alford Brothers Laundry Company and FFF Steam Laundry Company at 731–747 East Dayton Street. Its telephone exchange was "Badger 172."

In the 1880s, Madison had three very posh neighborhoods. Aristocrat Hill (now Mansion Hill) on Wisconsin Avenue and the Monona Clique on Monona Avenue both had roots in Madison's earliest days. After the factories at the foot of Lake Street closed about 1880, lower Langdon Street was gentrified with homes that rivaled those on Aristocrat Hill. In this view around 1905, the snow is marked with horse-and-cutter tracks.

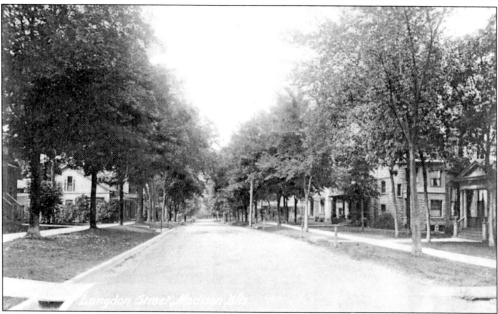

This view looks west from the 100 block of Langdon Street about 1920. The coming of the automobile meant that the gentry could live in Maple Bluff and Shorewood and still have easy access to downtown. Between 1900 and 1920, enrollment at the University of Wisconsin rose dramatically. On Langdon Street, wealthy homeowners began parceling off their grand lawns for new boardinghouses and fraternity houses to meet the demand for student lodgings.

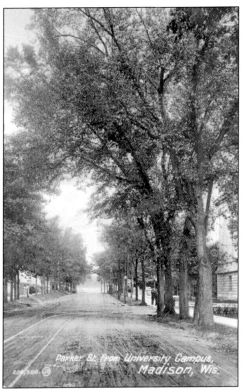

The Memorial Union opened in October 1928, replacing four large lakefront homes. When the University of Wisconsin president's house was razed in 1937 to make way for the Union Theatre, the degentrification of lower Langdon Street was complete. The president's house is just visible on the right in this view down unpaved "Parker Street," (a misprint; it was always Park Street). The university/state historical library (1900) is on the right.

Lower State and Langdon Streets, once an elite neighborhood, were increasingly dominated by the university and its environs. This lakefront view of the University of Wisconsin campus around 1904 shows from left to right the armory/gymnasium (1892), and the boathouse (1893), the second Science Hall (1882), Main (Bascom) Hall (1859), and Chemistry Hall (1885). Here Bascom Hall still has its dome, which burned in 1916.

Five

BODY AND SOUL

Hospitals and churches care for the body and for the soul. One came early to Madison, the other came late.

In Madison in the 1880s, victims of illness or injury were nearly always cared for at home. The health of citizens was considered a private matter and home was seen as the best and most appropriate placed to be cared for. For students and transients who fell ill far from home, there were few options. Hotels and a few small private hospitals offered a place to convalesce, if one could afford them. The jail might offer shelter and minimal care. But for a patient with a contagious disease, hotels and even the jail would likely be off limits.

Beginning in the 1880s, reformers in Madison began pushing for a city hospital. There were small, private hospitals in the city, but they were not open to everyone. It took 20 years of political wrangling and 20 years of failed plans and initiatives before Madison General Hospital opened in 1903. Over the next two decades, Madison went from 32 hospital beds to more than 300. Civic groups like the Madison Women's Club helped initiate public health programs, especially for the poor.

The first churches arrived almost as soon as the first settlers. They were tiny congregations meeting in homes or rented halls, with their pastors paid by Eastern missionary societies. Sixteen Episcopalians formed a congregation in 1839, the city's first. The Congregationalists built the first church in 1846, a simple frame structure on South Webster Street. Women dominated the church rolls and church activities in 19th-century Madison not least because of the churches' leading role in the temperance movement and in the "bar wars" that were a chronic feature of Madison's politics.

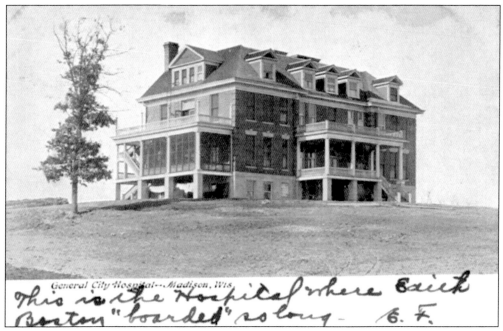

Madison General Hospital, seen here from Park Street, opened on October 5, 1903, under-funded from the start. Hailed as the "pride of Madison" when it opened, the hospital was described just five years later as "overcrowded," "unhealthy," and "cheaply built." The council's 1908 reforms improved the management of the hospital but did little to ease overcrowding.

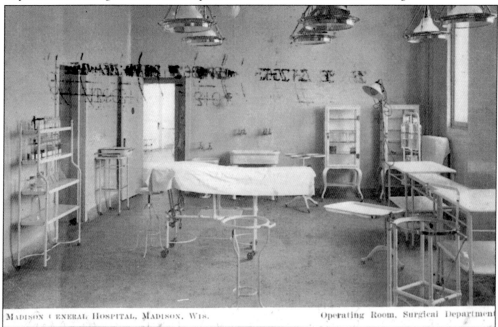

The surgery rooms at Madison General Hospital, seen here in 1907, were modern for their day. They shared the second floor with private patient rooms. The first floor housed wards and doctors' examining rooms. The kitchen and dining room were in the basement, and the nurses' quarters were on the third floor.

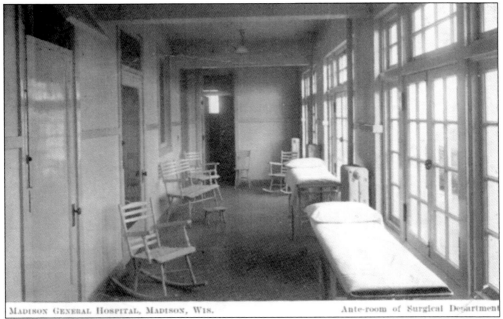

MADISON GENERAL HOSPITAL, MADISON, WIS. Ante-room of Surgical Department

This view shows Madison General Hospital's surgical "anteroom"—the recovery room—in 1906. Despite its perceived shortcomings, the Madison General Hospital was a welcome addition to the city. A letter in the *Madison Democrat* newspaper in March 1899 described the city's dire need for a public hospital. But the council and many residents were only beginning to see public health and health care as a municipal function.

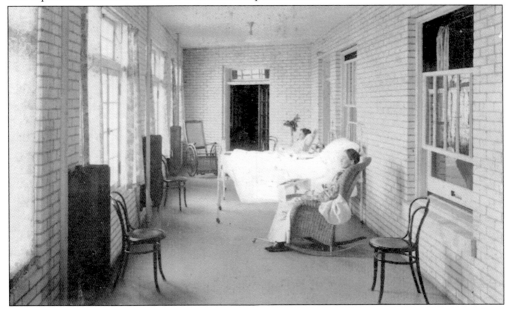

The hospital's solarium, seen here in 1906, offered patients healthy doses of sunshine and fresh air. The germ theory of disease was still relatively new to mainstream medical practice in 1903. Antibiotics would not see general use until the 1930s. The rising cost of care was already a public issue. In 1912, a hospital stay in Madison cost nearly $3 a day, and a private room was almost $5 a day.

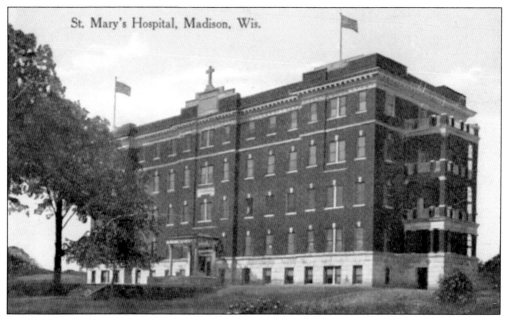

St. Mary's Hospital, Madison, Wis.

Madison Catholics had long wished for their own hospital in the city. Overcrowding at Madison General Hospital spurred them to action. One proposal fell through for a hospital near Tenney Park. In 1908, the St. Louis–based Sisters of St. Mary agreed to build a new 75-bed hospital on an old (and vacant) cemetery owned by the Madison diocese. St. Mary's Hospital opened at Mills and South Brooks Streets in 1911.

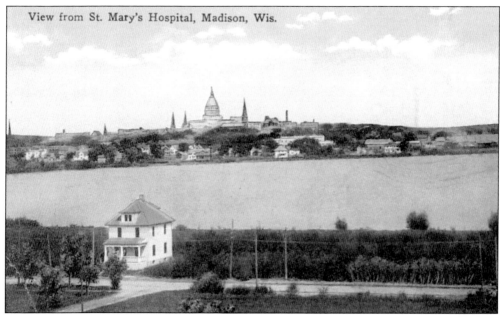

View from St. Mary's Hospital, Madison, Wis.

Like Madison General Hospital, St. Mary's Hospital was built in a sparsely developed neighborhood on the city's outskirts. There was wisdom in that choice. Since the 1870s, neighbors' objections had torpedoed one proposed city hospital after another—one of the main reasons it took 21 years of pushing and shoving to get Madison General Hospital built. This view looks east across Monona Bay around 1912. Park Street is in the foreground.

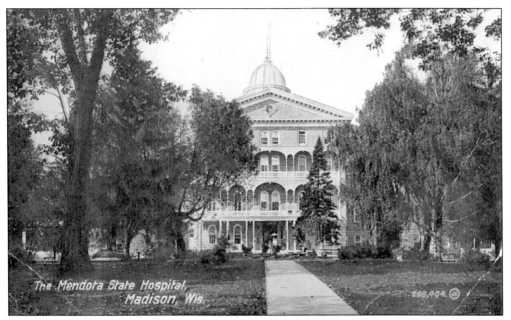

In 1854, a new Wisconsin law provided for a "state lunatic asylum" near Madison, one modeled after the then-modern hospital for the insane in Worcester, Massachusetts. A panel of commissioners chose a 104-acre site on the north side of Lake Mendota. After some wrangling over the plans, the main building and two wings were opened in July 1860. In December, the superintendent reported that he had admitted 89 patients.

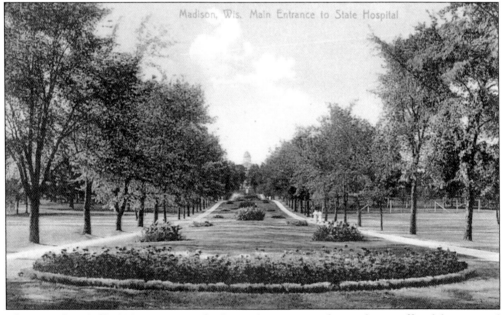

The state hospital's 104-acre grounds, its main entrance shown here, offered beauty and isolation. In 1870, the superintendent's annual report showed that the hospital held an average of 362 patients on any day, with a staff of two physicians, a matron, and seven attendants (four male, three female), in addition to cooks, food servers, laundresses, a seamstress, a fireman, a carpenter, an engineer, a bookkeeper, and a night watchman.

Hospital for Insane at Mendota, Wis

By 1880, the state hospital housed 582 patients in a facility for 500. In 1896, the superintendent reported that all the hospital's sewage was still being dumped into the lake, and much of its fresh water was drawn from the lake. After a typhoid outbreak in the hospital caused 10 deaths, improvements came quickly. In 1906, a new wing was added, plumbing was improved, and electric lights replaced the gas lamps.

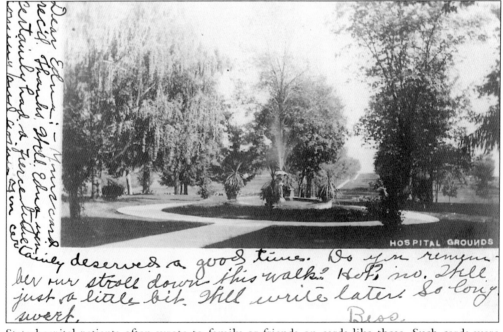

HOSPITAL GROUNDS

State hospital patients often wrote to family or friends on cards like these. Such cards were created by the hospital and made available to patients, in part to reassure relatives and other outsiders of the serene and pleasant surroundings in which the inmates lived. This view is of the hospital grounds about 1900.

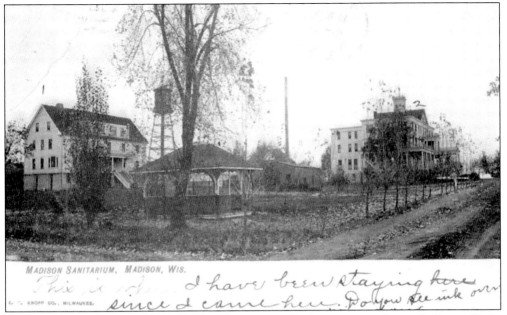

MADISON SANITARIUM, MADISON, WIS.

This is ... I have been staying here since I came here. Do you see ink over

The Madison Tuberculosis Sanitarium, seen here, was built in 1902 on the south shore of Lake Monona, east of the present John Nolen Drive. It was built and operated entirely with private funds and modest patient charges. It had room for 50 patients, three quarters of whom came from outside Madison. The fresh air, sunshine, rest, and nutrition offered here was an effective treatment for many tuberculosis patients.

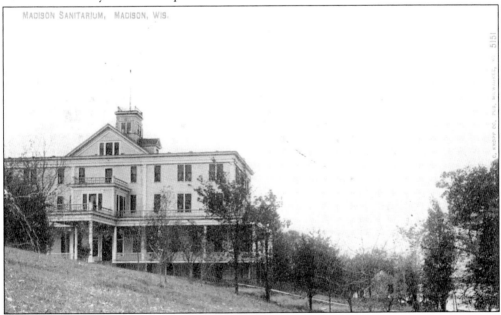

MADISON SANITARIUM, MADISON, WIS.

At the Madison Tuberculosis Sanitarium, patients "of all creeds and races" received occupational and physical therapy, massage, hydrotherapy, "electrical treatments," and counseling to restore them to health. "The very atmosphere seems pregnant with rest and quiet," wrote an unidentified author in the *Wisconsin State Journal* in 1921. This card and the next (page 78) were probably produced for the 1921 campaign to raise $100,000 to expand and modernize the facility.

The previous card shows the back of the main building of the Madison Tuberculosis Sanitarium. This view shows the main building (with cupola) and outbuildings. A 1921 article in the *Wisconsin State Journal* announced a fund-raising campaign for the sanitarium, described its benefits to patients and economic benefits ($100,000 per year) to the city, and noted that the institution had never requested or accepted a single dollar of public funds.

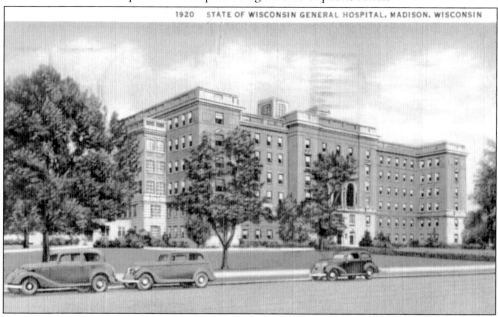

In 1902, Madison had just two small hospitals, one private, with a total of 32 beds. By 1920, there were eight hospitals in Madison offering more than 300 beds. The Wisconsin General Hospital (later University Hospital) opened on University Avenue in 1924. The new teaching hospital, seen here about 1935, allowed the university to expand its medical training program from two to four years in 1925.

Madison's oldest congregation, the Congregational Church, was organized in 1840. The members built a wooden church on Webster Street in 1846 but quickly outgrew it. They met at Bacon's Commercial College until the church shown here was finished in 1874 on West Washington Avenue, a block off the square. In 1930, the congregation built a new church on Breese Terrace. The 1874 church was demolished, replaced by a gasoline station.

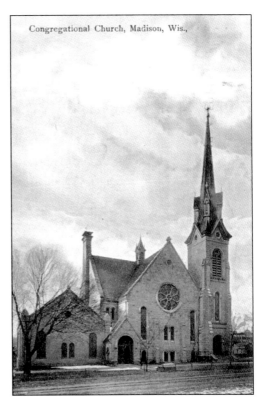

Congregational Church, Madison, Wis.,

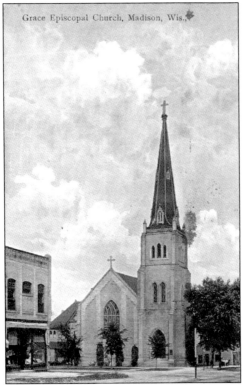

Grace Episcopal Church, Madison, Wis.,

Four churches have stood on the capitol square. Only one remains in the oldest-surviving building on the square. Grace Episcopal Church, completed in 1858 at 1 West Washington Avenue, is one of Wisconsin's finest examples of Gothic architecture. An 1898 article in the *Milwaukee Sentinel* called it "the oldest stone Episcopal church west of the Allegheny Mountains" and "an architectural wonder [that] brought great reputation to Madison."

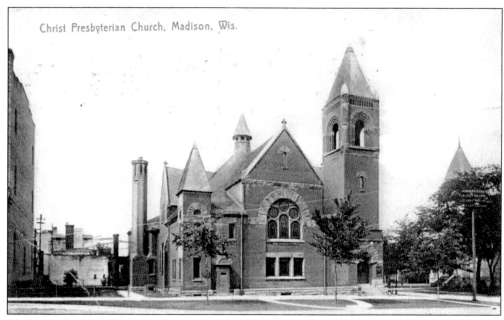

Christ Presbyterian Church, Madison, Wis.

Christ Presbyterian Church was organized in 1851. Its chief organizer was Prof. John W. Sterling, widely considered to be the "father of the University of Wisconsin." A church building was completed in 1853 where the Masonic temple now stands. In 1892, the congregation erected a new building adjacent to the 1858 city hall (at far left) on Wisconsin Avenue. That church, seen here in 1906, was enlarged in 1926 and demolished about 1960.

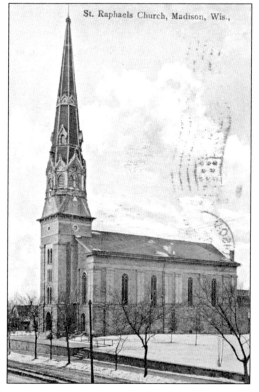

St. Raphaels Church, Madison, Wis.,

Irish immigrants organized St. Raphael's Catholic Church in 1842. Masses were held in homes or in the capitol building until 1854 when construction began at 222 West Morris (now Main) Street on land donated by James Doty. The sandstone church was dedicated in 1869, and its spire and bells were added in 1885. A 2005 arsonist's fire left the church heavily damaged, and it was demolished in 2008.

In 1857, several German families from St. Raphael's Catholic Church built a new parish on west Johnson Street. Parochial school classes were held in the church, with pews for desks and curtains drawn across the altar. The current church, seen here, was completed on the same site in 1869. The School Sisters of Notre Dame convent (now St. Paul House) was built behind the church on Gorham Street in 1894.

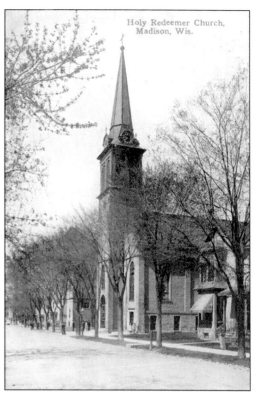

By the 1880s, St. Raphael's Catholic Church was again overcrowded, and some 250 Irish families split off to form St. Patrick's Church. St. Raphael's purchased two lots in the 400 block of East Main Street and sold them to the new congregation for $1. The present St. Patrick's Church was dedicated in 1889. A school was added in 1907, operating until 1977 when declining enrollments forced it to close.

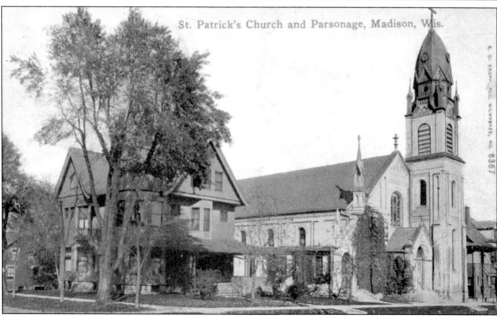

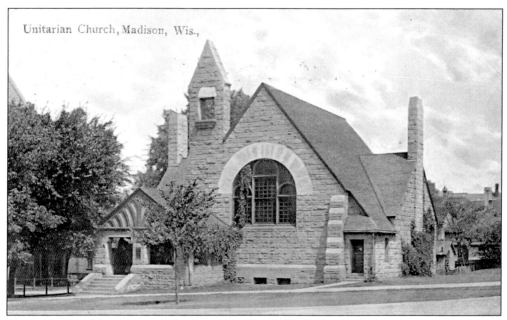

Unitarian Church, Madison, Wis.,

Madison's first Unitarian meetings were held in the 1860s, ending around 1870. A new Unitarian Society formed in 1879, meeting in a synagogue on East Washington Avenue and in Hooley's Opera House on South Pinckney Street. They built the church pictured here in 1886 on Wisconsin Avenue next to the 1871 post office. In 1947, the society commissioned Frank Lloyd Wright to design a new meetinghouse on University Bay Drive.

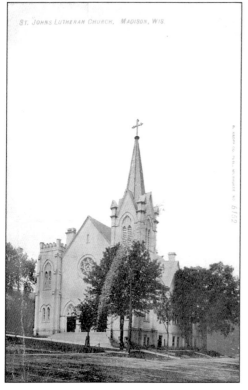

ST. JOHNS LUTHERAN CHURCH, MADISON, WIS.

German immigrants organized St. John's Lutheran Church in Madison in 1856. They met in homes or rented halls before building a small frame church in the 400 block of East Morris (Main) Street. In 1867, they built a larger frame church on East Washington Avenue at North Hancock Street. The current church, seen here, was completed on the same site in 1905.

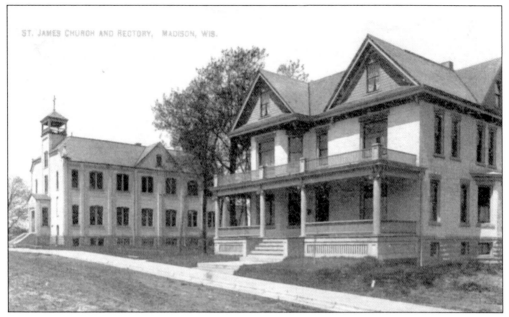

St. James Catholic Church and School (at left, above) was incorporated in May 1905 and opened in February 1906 just off South Charter Street. The church occupied the ground floor. The second floor housed the school—85 students in six grades. In 1912, the parish began building a new church next door and converted the old chapel to classrooms. The school building was replaced in 1958.

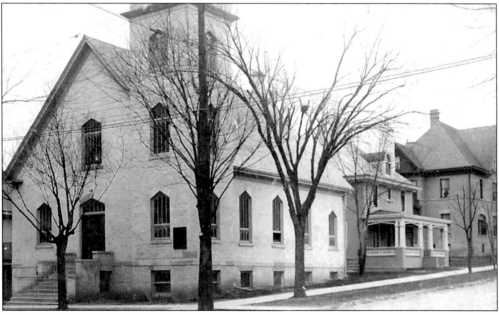

This church, at Jennifer and Ingersoll Streets, was built in 1908 as Immanuel Lutheran Church. It was chartered in 1903 by German Lutherans who had moved to Madison from the Portage area. The parsonage behind the church was built by the pastor and purchased by the church in 1913. This building served the growing congregation until 1957 and has served other congregations since then.

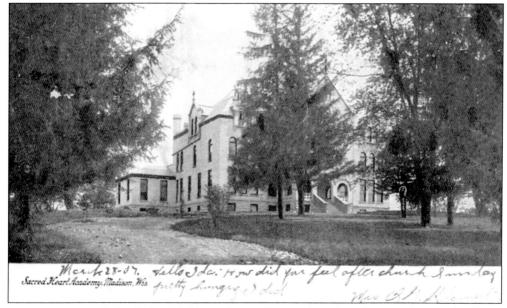

Sacred Heart Academy, Madison, Wis. *March 28-07. Hello Ida: how did you feel after church Sunday pretty hungry I did. Mrs G. L. R*

Former governor Cadwallader Washburn donated his rural Madison home, Edgewood Villa, to the Sinsinawa Dominican Sisters, who opened it in 1881 as St. Regina Academy, a Catholic girls' school. The villa burned in 1895, killing three students. Rebuilt, the school (above) reopened in 1896 as Sacred Heart Academy at Edgewood. Boys were admitted, and in 1924, junior college courses were offered in a new building and under a new name—Edgewood Academy.

To Native Americans, the four lakes seem to have been a very special place. Early European visitors reported no Native American villages on the isthmus but many in the surrounding area. The Mound Builders (300–1400 AD) apparently thought it a sacred place. They built more than 1,000 effigy mounds around the lakes. Mendota Drive, seen here, was one of the early "pleasure drives" built by and for Madison's carriage set.

Six

The University

The period of the 1880s to the 1920s was one of tremendous growth for the University of Wisconsin—in the size of its faculty and student body, in the breadth and depth of its academic offerings, and in its recognition and stature among the nation's colleges and universities. When the university was chartered by the legislature in 1848, most higher education was provided by private colleges dedicated to a "classical education" offered mainly to the privileged classes. The idea that a state university should serve *all* the citizens of the state was revolutionary. But as early as 1858, a Wisconsin legislative committee declared that the university, as a state-supported college, "shall primarily be adapted to popular needs" and "shall be arranged to meet as fully as possible the wants of the greatest number of our citizens."

That is the essence of "the Wisconsin Idea," which proclaims, "the boundaries of the university are the boundaries of the state." No one knows who first called it "the Wisconsin Idea," but by the early 20th century, it had gained national recognition and became a model for other state-supported colleges and universities.

While the university was often criticized as a hotbed of "godless radicalism," its board of regents firmly defended the principle of academic freedom. In 1894, economics professor Richard Ely was publicly charged with teaching "pernicious socialist and anarchist doctrines." The board of regents investigated, and its report went beyond exonerating Ely, stating, "In all lines of academic investigation, it is of the utmost importance that the investigator should be absolutely free to follow the indications of truth wherever they may lead." The regents' stalwart defense of "that continual and fearless sifting and winnowing" of ideas in the pursuit of truth became a basic tenet of the university and one of the cornerstones of intellectual and academic freedom in America.

Prof. John W. Sterling began teaching the first University of Wisconsin classes in February 1850 in the Madison Female Academy building in the first block of West Johnson Street, where Madison's first high school was later built in 1908 (see page 47). This postcard was issued as a souvenir of the 1907 University of Wisconsin homecoming.

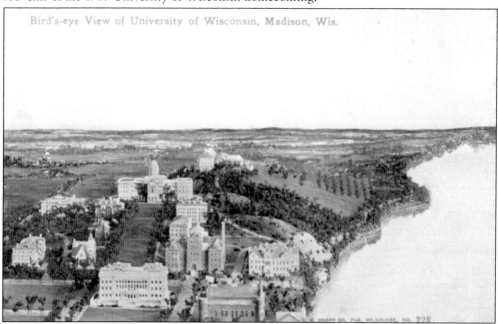

South Hall, seen here left of Bascom Hall (1859) around 1915, opened in November 1851. With classrooms and faculty and student housing, it was the university's only building for four years. At far left is old Chadbourne Hall (1870–1957). Chemistry Hall (1885–1968) is to the right of Science Hall (1887). The roof of the old boathouse (1893–1968) is visible next to the gymnasium and armory (Red Gym, 1892).

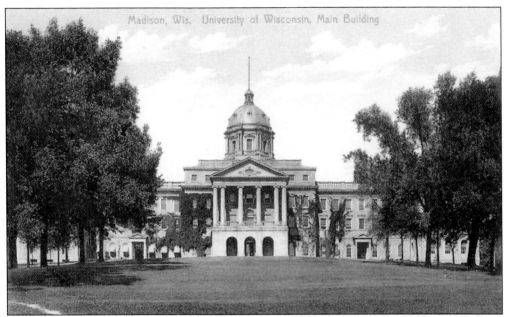

Bascom Hall, seen about 1915, was originally called Main Edifice, then Main Hall, University Hall, and finally Bascom Hall, after university president John Bascom, whose tenure (1874–1887) laid the foundations of the modern school. Bascom Hall was completed in 1859 and remodeled or expanded several times. It was the third building on campus and the first dedicated solely to instruction. North and South Halls both included student and faculty housing.

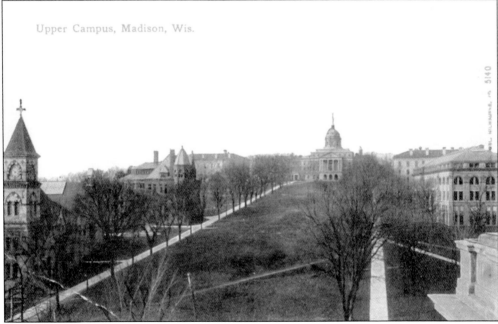

Upper Campus, Madison, Wis.

The buildings in this view from about 1915, from left to right, are the 1880 Assembly Hall (old music hall), old law school (1891), South Hall (1850), Bascom Hall (1859), and North Hall (1855). The building at far right, now the education building, was built in 1900 to house the engineering school. Engineering moved to the west campus in 1930.

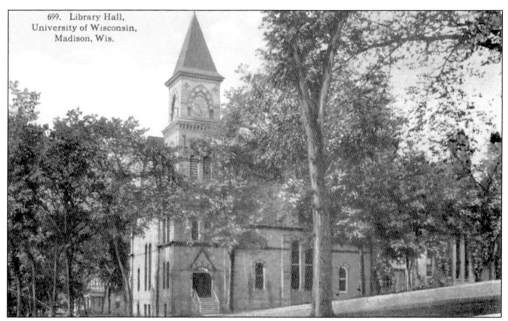

699. Library Hall,
University of Wisconsin,
Madison, Wis.

One of president John Bascom's achievements was the building of the Assembly Hall and library, seen here. Built in 1878, it replaced a cramped and overcrowded library in Main (Bascom) Hall and provided the first large assembly room on campus. Its functions were taken over by the Red Gym in 1892 and the new university/state historical library in 1900. The music department was housed here from 1900 to 1969.

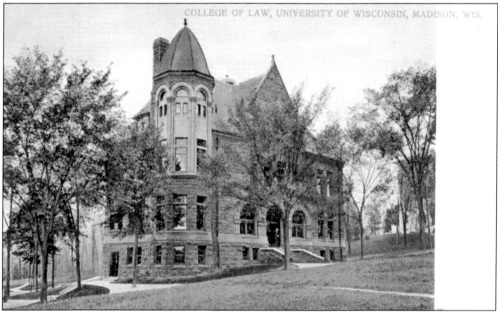

COLLEGE OF LAW, UNIVERSITY OF WISCONSIN, MADISON, WIS.

The regents created the law school in 1857, but it did not actually accept its first students until 1869. Even then, the first classes met in the unfinished capitol and later in two rooms over a downtown saloon. The law building, seen here, opened in 1891. A 1939 addition provided case-law discussion rooms and a new library. A 1963 addition replaced what remained of the original brownstone.

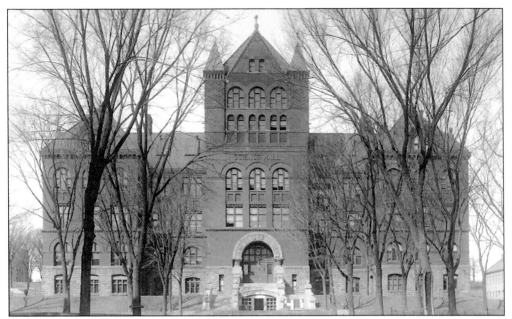

The new Science Hall was completed in 1887 after the first Science Hall (1875) burned in 1884. The University of Wisconsin Medical School anatomy laboratories occupied the top spaces of the new Science Hall for several years after 1904, winching human cadavers up from the basement morgue. Geography students were still finding human body parts in the attic in the mid-1970s—one of many factors contributing to the "haunting" of Science Hall.

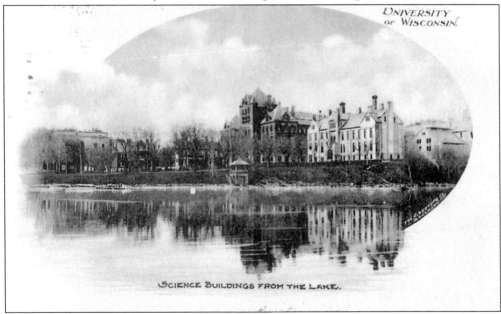

UNIVERSITY OF WISCONSIN.

SCIENCE BUILDINGS FROM THE LAKE.

The first chemistry department was in the basement of Main (Bascom) Hall. Its unpleasant effects on the classrooms above were among the reasons for building the first Science Hall in 1875. That building burned in 1884, and a new fireproof Chemistry Hall opened in 1885, next to the present Science Hall, both seen here. Chemistry Hall became the chemical engineering building in 1905 and was torn down in 1968.

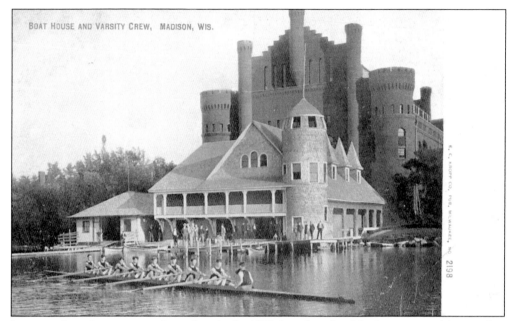

Intramural rowing came to the university in 1874, but the school had no competitive rowing club until 1891. The club held its first regatta in 1893 and began planning for a boathouse. With a long-term lease from the regents on the lakefront behind the new armory, the club began raising money from students and other donors. After a few financial fits and starts, the boathouse was opened in May 1893.

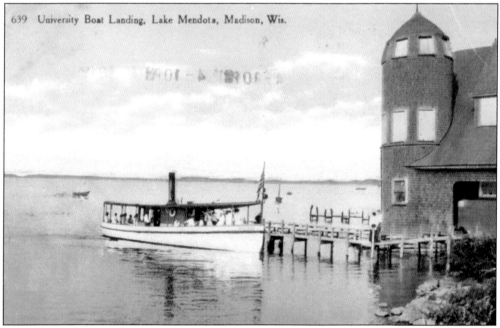

639 University Boat Landing, Lake Mendota, Madison, Wis.

The boathouse had three channels to the lake, storage room for 80 boats and several rowing shells, a bait shop, and a large club room upstairs. The public could rent boats for 15¢ per hour. The club's lease expired in 1908 and the University of Wisconsin took ownership of the boathouse. In 1963, it was partially demolished to make room for the alumni center.

90

The University of Wisconsin's first gymnasium was a cheaply built barn on the site of the present carillon tower. Built in 1870, it burned 11 years later, to no one's sorrow. The new gymnasium and armory, at right, opened on Langdon Street in 1892. The first floor held offices, bowling alleys, lockers, and a swimming pool, for men only. The large second-floor gymnasium was also suitable for military drill.

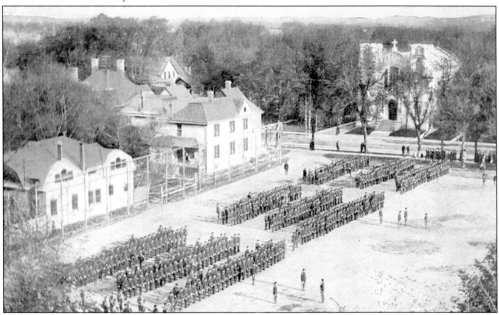

Here the university battalion drills on what would become the Library Mall, with State Street in the background. With enrollments rising, the armory/gymnasium was quickly overcrowded and obsolete. Students packed into the gymnasium for basketball games until 1930, when the field house opened. Nearly torn down in the late 1940s, the old armory was restored and remodeled in the 1990s as the campus visitor center.

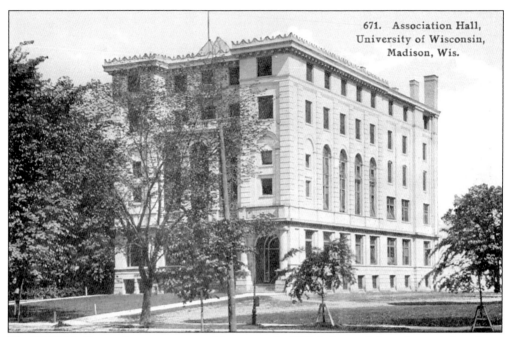

671. Association Hall,
University of Wisconsin,
Madison, Wis.

The YMCA built a student center west of the armory in 1905. It featured the only men's dormitory and the only cafeteria on campus, and it became in effect the student union, with men's housing on the upper levels and activity rooms and club offices below. Built to last 20 years, it served for 40, long after the Memorial Union and a new downtown YMCA were built.

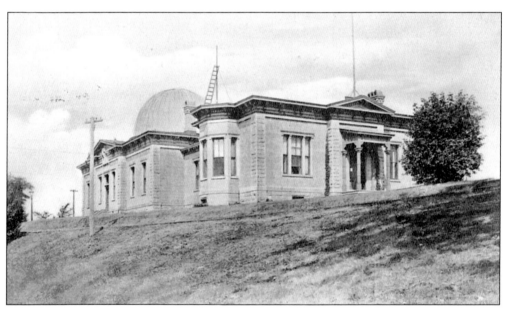

Former governor Cadwallader Washburn donated the entire cost of the University of Wisconsin's first astronomical observatory. Built in 1877, it still houses the 15.6-inch refracting telescope installed in 1881. It was a major research facility until the university opened a new observatory at Pine Bluff in 1959. The old telescope is still used by first-year astronomy students and public school groups and is open to the public two nights each month.

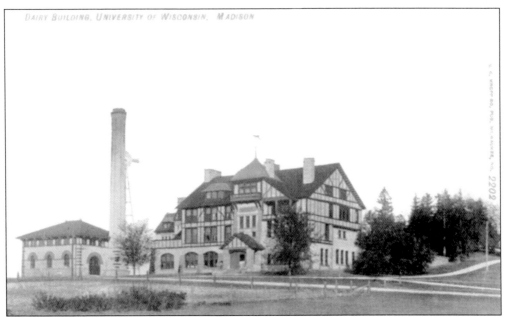

In June 1890 in South Hall, Prof. Stephen Babcock developed a simple, foolproof test for measuring the butterfat content of milk. That fall, enrollment in the University of Wisconsin's dairy course jumped from 20 to 75. In response, the university built the first permanent dairy instruction building in the Western Hemisphere, Hiram Smith Hall, in 1890 and 1891 (center). By 1900, the growing agriculture campus needed its own heating plant, seen at left.

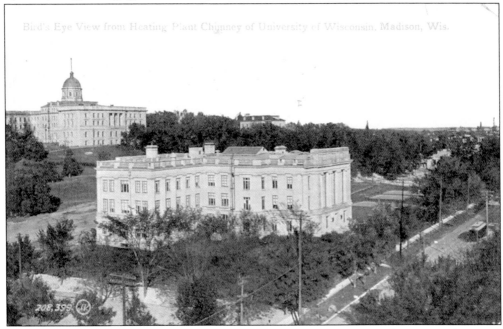

When Chemistry Hall was built on Park Street in 1885, some critics said it was too large and that it would take a century to reach capacity. It was bursting at the seams in 20 years. The regents built a new Chemistry Hall on University Avenue in 1905. Built in a cruciform shape, seen here, it was enlarged several times and was renamed Chamberlin Hall in 1975.

The agriculture department was first housed in South Hall. Growing enrollments in the agricultural courses—from 19 students in 1886 to 196 in 1901—caused intense crowding, and in 1903, Agriculture Hall opened west of Bascom Hall. The two-story octagonal wing at right housed the agriculture library and an auditorium. It is still called "Ag Hall," although many of the subdisciplines that started there now have their own buildings on campus.

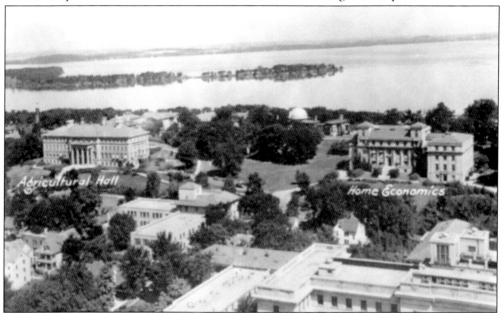

The somewhat-lopsided home economics building, completed in 1914 on Linden Hill, housed the home economics department and the university extension. The missing west wing was not built until 1953. The white frame house just down the hill was the "practice cottage" where home economics students honed their practical skills. Built around 1900 as a private home, it was acquired by the university in 1911 and used until 1930.

94

The first two buildings on Henry Mall were the agricultural engineering building (1905), at right, and the agronomy building (1907). The latter was the first reinforced-concrete building on the university campus. Aldo Leopold's Department of Wildlife Management was housed in the agricultural engineering building for a time and many important advances in the field of agricultural engineering were hatched there. Henry Mall is named for Agricultural College dean William Henry.

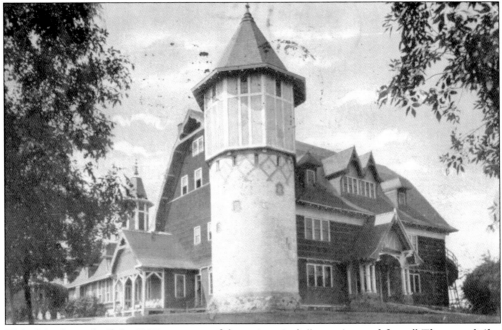

This dairy barn, built in 1897, was part of the university's "experimental farm." The round silo, topped by a water tank, was an experiment—one of the world's first tower silos. On the back of the building, a spiral ramp (not visible here) allowed a team of horses to pull a loaded hay wagon up to the third-floor hayloft. The barn also featured electric lighting—another first.

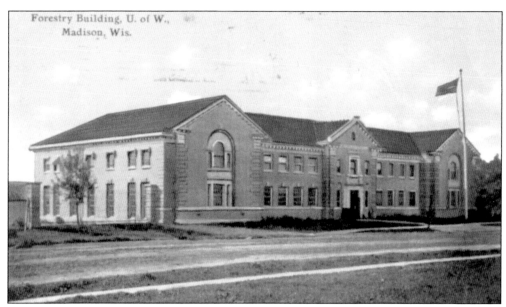

Forestry Building, U. of W., Madison, Wis.

In 1905, the U.S. Department of Agriculture chose the University of Wisconsin over the state universities in Michigan and Minnesota as the location for its new, centralized Forest Products Laboratory, which opened in 1910 on University Avenue. During World War I, the laboratory conducted crucial testing of woods, glues, lamination processes, and production techniques for wood and fabric warplanes. It moved to new quarters in 1931, and the building was taken over by the engineering school.

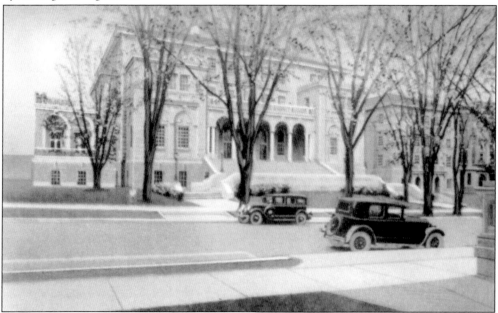

In 1904, university president Charles Van Hise called for a student union building to provide for "the communal life of instructors and students in work, in play, and in social relations." After many delays, ground was finally broken in 1925, and the building was dedicated three years later. This view shows the Memorial Union before the addition of the Memorial Union Theatre in 1937.

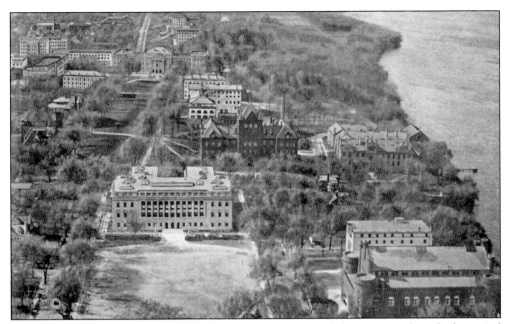

By the mid-1890s, the 1878 university library was so crowded that some students had to stand while studying, and there was no room for new books. The state's historical library, housed in the capitol, was overflowing. Regents and legislators agreed on a novel solution—a combined university and state historical library on the campus, seen at middle left. Construction began in 1895 but was not completed until 1900.

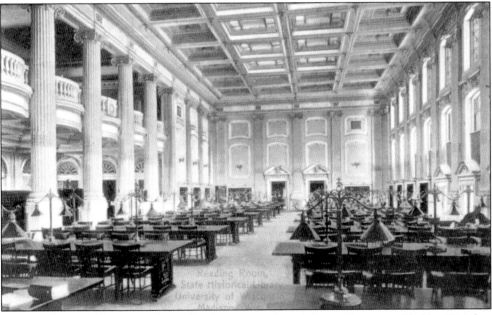

Space in the new library was immediately at a premium. New stacks were added in 1914, but after World War II, the library had to set up Quonset huts for storage and study areas. In the library catalog, many books were simply marked as "inaccessible." The university moved to the new Memorial Library in 1952 and the Wisconsin State Historical Library was still full. This view is of the main reading room.

The 50-acre site that became Camp Randall was originally owned by the state agricultural society and used for state fairs. During the Civil War, 70,000 Union soldiers trained here and 1,400 Confederate prisoners were held here. After the war, veterans were outraged when plans were announced to divide the property into residential lots. In 1893, the state purchased the property and gave it to the university.

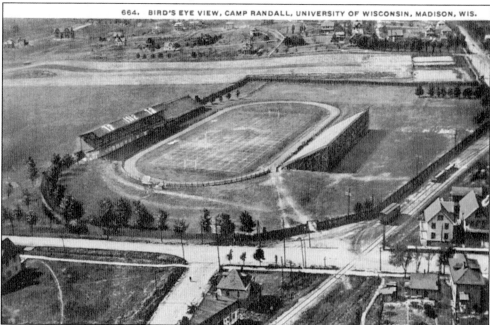

The university had already built a stadium at Camp Randall. The first game there was a football match against the Minnesota Gophers in 1895. The Badgers won 6-0. In this view, Randall Street runs left to right, crossing Johnson Street at lower right. University Avenue is just visible in the upper-right corner, intersecting Breese Terrace.

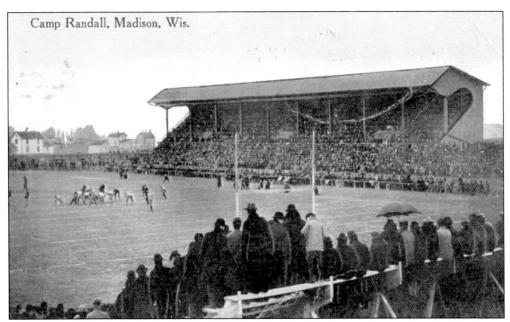

The old stadium, seen here, had a total seating capacity of around 3,000, but games were attended by up to 15,000 fans, most standing around the field. At the 1915 homecoming game, a section of rented, temporary bleachers collapsed, dropping 1,800 fans to the ground. There were no serious injuries and only a 15-minute delay in the game. But there were immediate calls for a new larger and safer stadium.

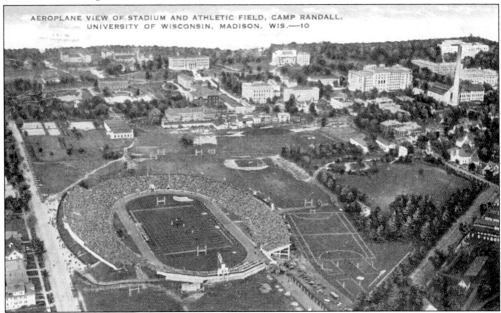

AEROPLANE VIEW OF STADIUM AND ATHLETIC FIELD, CAMP RANDALL, UNIVERSITY OF WISCONSIN, MADISON, WIS.—10

The new stadium, seen here in the 1940s, was ready for the 1917 opening game against Beloit College. The Badgers won 34-0. It was dedicated at that year's homecoming game against Minnesota when the Badgers won again. There have never been enough seats. The bleachers went higher, and in 1958, the field was lowered 10 feet to add 10,000 new seats. The current capacity tops 80,000 and will almost certainly keep rising.

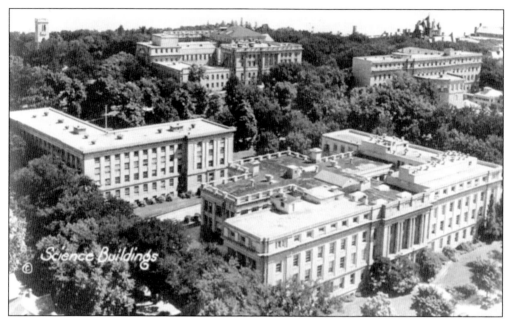

The darker roofs of Chamberlin Hall, lower right, reveal the 1905 cruciform building in this 1950 view. The 1912 (west) and 1929 (east) additions face University Avenue. Behind is Sterling Hall (1915), which housed the physics, political economy, and commerce departments. A south side addition (1958) later housed the Army Math Research Center. Birge Hall, built as the botany building (1912), is at the upper right, and the 1936 carillon tower is at the upper left.

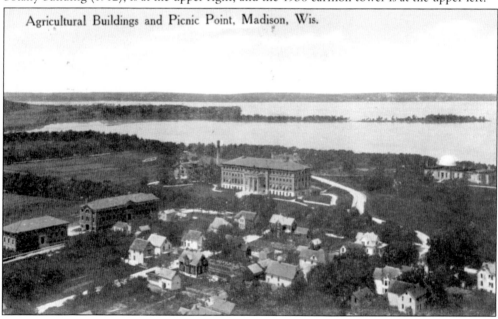

In this view of the College of Agriculture around 1910, Agriculture Hall dominates Observatory Hill, and Henry Mall and Lorch Street are lined with faculty houses and other private homes. Enrollment in agriculture courses was growing fast, agriculture faculty were gaining world renown, and the "Wisconsin Idea" and the University Extension helped make the University of Wisconsin a world leader in advancing the science and practice of agriculture.

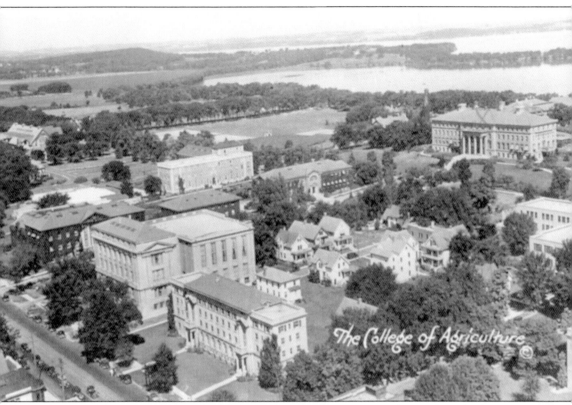

The College of Agriculture

In this view, probably from the 1940s, Agriculture Hall is just one of many large buildings on the near-west campus. Clockwise from Agriculture Hall is the Orthopedic Hospital (far right), which was built in 1930 as a children's hospital. With a capacity of 113 patients, it was a busy place, especially during the polio epidemic of the early 1950s. At center front is the 1926 nurses' dormitory, home of the university's nurse training program. When built, it housed 96 student nurses next door to the Wisconsin General Hospital (University Hospital). West of the nurses' dormitory is Wisconsin High School, built in 1913 as a training school for teachers and a laboratory for teaching methods until the mid-1960s. At the far upper left is the Stock Pavilion, built in 1909 to house the university's horses and as a venue for statewide livestock shows. The Stock Pavilion's 5,500-seat arena turned out to have excellent acoustics, and it was the site of many performances by musicians, orchestras, and famous speakers—a fact that earned it the nickname "Cowlesium."

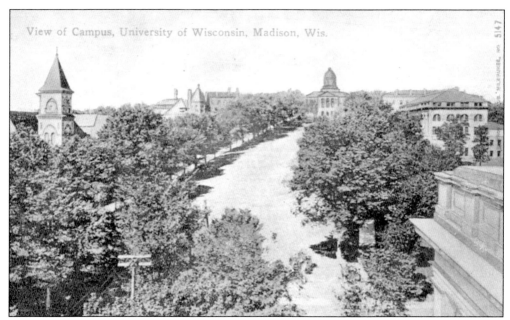

The University of Wisconsin campus has grown far beyond the original College Hill purchased by the board of regents in 1848. But many still consider Bascom Hill to be the heart of the university. It faces the capitol building, evoking the give and take between the university and the state that has enriched both. The university's oldest buildings are here, where some of its greatest scientific and academic accomplishments have occurred.

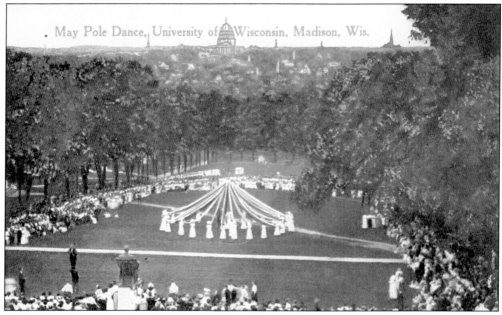

The statue of Abraham Lincoln, dedicated in 1909 and donated by a cousin of Frank Lloyd Wright, has presided over everything from May Day celebrations like this one around 1910 to 1960s student unrest. Through it all, the university remains true to its commitment that "the great state University of Wisconsin should ever encourage that continual and fearless sifting and winnowing by which alone the truth can be found."

Seven

THE WATERS

The Ho-Chunk simply called them "the four lakes," or "tay-cho-per-ah." A 1932 survey by Orson Lyon got a little more specific, calling them "Lakes One through Four," and so they remained officially named until 1854.

That year, at the request of Leonard Farwell, Madison's leading developer and promoter of the day, the legislature adopted the lakes' present names. All four were derived from Native American words, as Farwell intended, but none is Ho-Chunk/Winnebago in origin, and only two have known meanings—in Chippewa—Waubesa, or "swan," and Kegonsa, or "fish."

Lake Wingra was mentioned in early descriptions only as a pond. Wingra and its extensive marsh, both spring-fed, empty into Monona Bay. Civilized now into Wingra Creek, the lake's outlet in James Doty's day was probably a broad, meandering wetland flowage into Lake Monona. Wingra is the only one of the five lakes with a Ho-Chunk name, derived from the word for "duck."

The stream that connects the four lakes was named Yahara River by the U.S. Board of Geographic Names in 1903. The oldest maps identify it as the Catfish River or the River of the Four Lakes. Doty's 1836 plat map shows a winding river with its Mendota outlet near the present location and its Monona inlet a few blocks farther east of the present site. At the time, the areas east of Blount Street and west of Bassett Street were mostly cattail marsh.

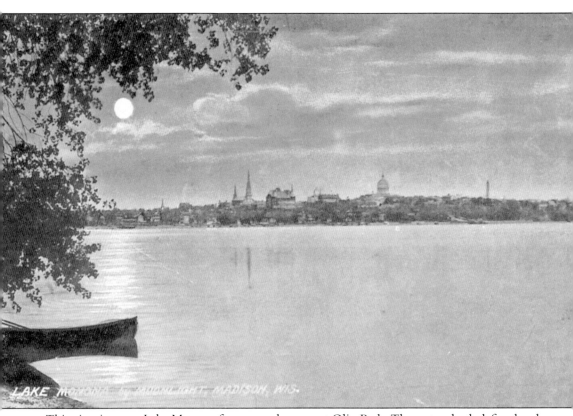

LAKE MONONA by MOONLIGHT, MADISON, WIS.

This view is across Lake Monona from near the present Olin Park. The waters both defined and constrained Madison's early development. James Doty chose the highest point on the isthmus for the site of his territorial capitol building, and his future town site extended a mile or so to the northeast and southwest. Beyond those boundaries, much of the land was marshy and remained so into the early 20th century. One of the most glaring shortcomings in Doty's 1836 plat of Madison was the lack of any parkland along the lakeshores. The only public space was the capitol park. All of the lakefront land was reserved for private property. The lakeshore around Park, Lake, and lower Langdon Streets was occupied by industries. In the village era, a few homes lined Lake Monona until the railroad crossed the isthmus there. By the late 19th century, the Monona shore of the isthmus was lined with private boathouses, many of them aging, ramshackle eyesores and a continuing source of public controversy.

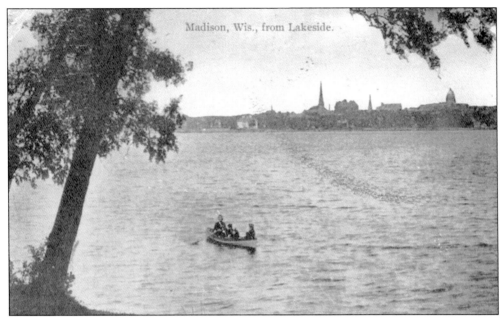

In 1854, as eastern newspapers praised Madison as a tourist destination, Elisha Burdick and George Delaplaine, two Madison developers, opened the Water Cure, a resort-spa on Lake Monona in the middle of what is now Olin Park. It was not a financial success, and it closed in 1857. Nine years later, they remodeled and reopened it as a summer resort hotel called Lakeside House. This view looks across Lake Monona from the resort.

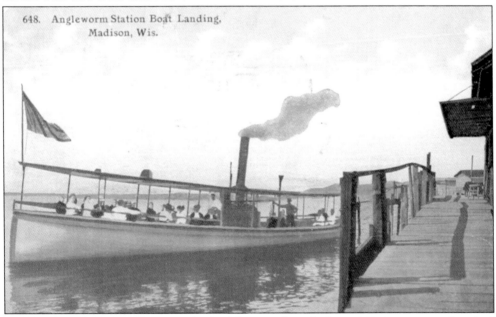

The first excursion steamboat to ply the lakes was launched in 1854. Its owner advertised "fishing excursions and pleasure rides" on Lake Mendota. The trim excursion steamer seen here is leaving Angleworm station on Lake Monona at the foot of South Carroll Street. In the 1870s, there were four busy commercial steamers carrying tourists to and from the parks and resorts on the south side of Lake Monona.

By the early 1890s, small, private parks dotted Madison's Lake Mendota and Lake Monona shores, but the only public parks in the city were the capitol park and the small Orton Park, a former cemetery on Spaight Street. Pleasure driving was popular among the carriage set, but destinations and routes, like Sherman Avenue (above) and the unidentified country lane (below), were few.

In 1888, George Raymer, publisher of the *Madison Democrat*, bought 150 acres west of Picnic Point, built a two-mile-long winding parkway along the lake, and opened it to the public. Farther west, university professor Edward Owen bought 14 wooded acres in 1892 and opened a parkway from Regent Street to Sunset Point (now Hoyt Park). Owen donated the park and parkway to a citizens' group, which maintained them.

Raymer's Eagle Heights parkway was difficult to reach from the city. Led by Madison attorney John Olin, the citizens' group raised money to build Willow Drive, which skirted University Bay and connected with Raymer's parkway, creating the 12-mile-long Lake Mendota Drive (also known as University Drive), pictured here. Olin's work improving the city made him one of the most important private citizens in Madison's history.

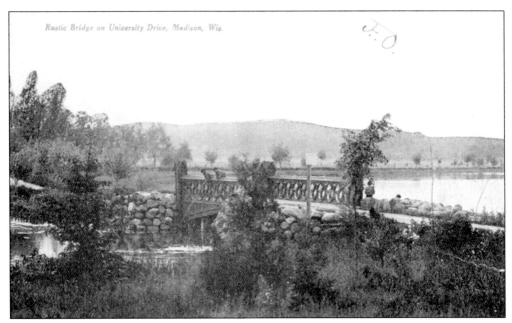

This rustic bridge was one of several along the Lake Mendota Drive parkway. Narrow, rutted, often muddy, and sometimes impassable, the parkway was still a success. In 1894, Olin's citizen group incorporated as the Madison Park and Pleasure Drive Association (MPPDA). MPPDA also built Farwell Drive, a carriage parkway skirting the east shore of Lake Mendota to Governor's Island.

The Cascades, Tenney Park,
Madison, Wis.

In 1899, Orton Park and the capitol grounds were still the only public, open spaces in the city. Several Lake Mendota property owners, led by brewer Joseph Hausmann, offered the city 460 feet of lake frontage near the Yahara River outlet (above) at a bargain price. Madison attorney Daniel Kent Tenney acted first; he bought the land and offered it to the MPPDA with an additional donation for its maintenance.

Bridge and Drive, Tenney Park, Madison, Wis.

Tenney's gift required the MPPDA to raise another $2,500, which it quickly did. The first $1,000 came from Sherman Avenue residents, and the remaining $1,500 was from the city. The city council chose the name Tenney Park. With Tenney's gift, the MPPDA's mission shifted from pleasure drives outside the city for the upper crust to parks and open space inside the city for the middle and working classes.

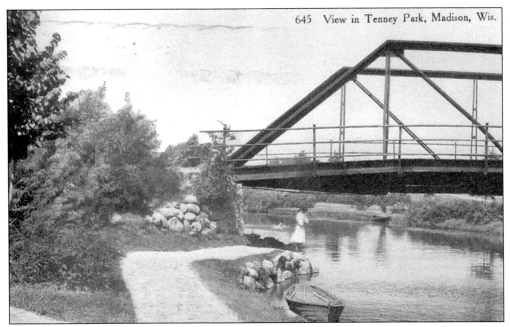

John Olin believed strongly that creating public parks was the city's responsibility. But he also knew that the city's resources were strained to build the new municipal sewer and water systems. So the MPPDA assumed the role of the city's parks department. The city did not hire its own parks superintendent until 1905.

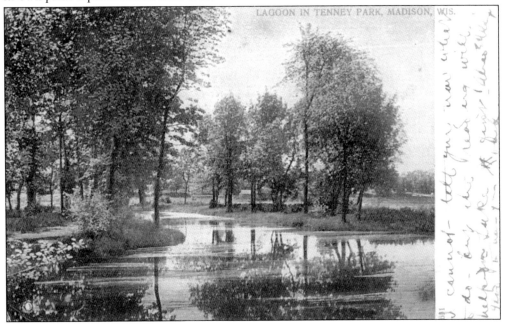

At first, Tenney Park (above) was mostly marsh. The MPPDA hired O. C. Simonds, a famous Chicago landscape architect, to design improvements for the park. Before work began on Simonds's plans for the park, Olin hired Madison contractor Leonard C. Gay to pump the marsh and test the substrata. A few years later, Olin strongly denounced Gay's plan to build Madison's first skyscraper.

The MPPDA dropped its dues from $25 to $5 and sent postcards like these to solicit new members among Madison's middle and working classes. Together, Daniel Kent Tenney and John Olin set into motion the development of Madison's park system, with far-reaching changes in the city's physical character. In fact, they were often bitterly at odds over other issues, and they argued about many details of the development of Tenney Park (above).

In 1903, the city government finally began to awaken to its responsibility for public parks. It issued the first municipal bonds for park development. There was strong and vocal opposition from business leaders, some of whom argued that Tenney Park (above) and other MPPDA projects were developed by the rich for the rich. Olin's arguments prevailed, and two years later, the city passed an even larger bond issue for parks.

The city contributed only 20 percent of the $15,000 cost of developing Tenney Park (above). In 1905, Madison hired Emil Mische as its first parks superintendent. His $1,200 salary was shared between the city and the MPPDA. Mische left for a better-paying job in 1907. His successor, recruited by Olin, was John Nolen, the landscape architect who became one of America's foremost urban planners.

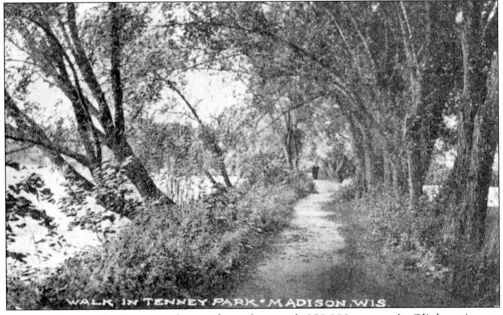

In 1908, the city finally enacted a tax for parks, worth $50,000 a year. At Olin's urging, to counter critics of the tax, a committee studied the parks' impact on Madison. Its 1909 report stated that "parks, drives, playgrounds, and open spaces," like Tenney Park (above), added measurably to Madison's property values. Olin retired from the MPPDA that year, already touched by the Parkinson's disease that claimed his life in 1924.

G 30588 Bridge and Lagoon, Tenney Park, Madison, Wisconsin.

[handwritten postcard message]

Long after John Olin retired from the MPPDA in 1909, he was still a strong voice in favor of public spaces and beautification. In 1923, the members of the German Presbyterian Church on Webster Street offered their historic church building to the city, which proposed relocating it to Tenney Park (above) for a museum. Olin spoke out strongly against the move, and the idea was dropped.

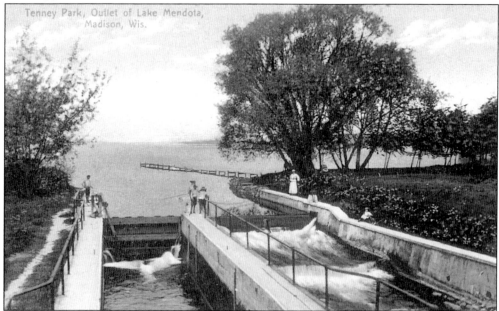

Tenney Park, Outlet of Lake Mendota, Madison, Wis.

Olin and the MPPDA had a profound and lasting effect on Madison's character. Beginning with Tenney Park, seen here, the city enjoyed a dramatic expansion of parkland and public spaces open to everyone. In 1890, the capitol park and three-acre Orton Park were the city's only public spaces. By 1909, the city had more than 225 acres of parkland and nearly eight miles of public lakeshore.

THE YAHARA RIVER, TENNEY PARK, MADISON, WIS.

In 1903, the Yahara River (above and below) was a narrow, winding, swampy creek dotted with industries, its banks described by the *Wisconsin State Journal* as "a dumping place for defunct horses, cats, and dogs." Olin proposed a sweeping project to turn the Yahara River into a public parkway and to open a navigable path between Lakes Mendota and Monona.

Yahara Parkway,
Madison, Wis.

With the help of Madison's leading citizens and enthusiastic support from its newspapers, Olin raised $20,500 for Yahara River improvement, $5,000 more than requested. Many of the pledges were for $5, the minimum dues for MPPDA membership. The *Wisconsin State Journal* estimated that contributions came from one in five households in the city and from many families of limited means.

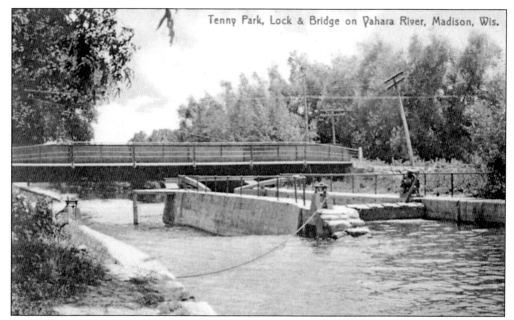

Tenny Park, Lock & Bridge on Yahara River, Madison, Wis.

To make the river navigable, John Olin's plan included locks (above) at the river's Lake Mendota inlet and dredging and straightening of the waterway. He convinced the city and the railroads to raise all eight bridges across the river to give boats a minimum of eight feet of headway. Support for the project was so strong that property owners along the river donated nearly all the land needed for the parkway.

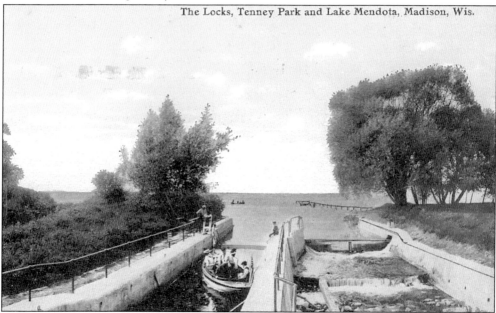

The Locks, Tenney Park and Lake Mendota, Madison, Wis.

The only real opposition to the Yahara River parkway, seen above, came from an unexpected quarter. Daniel Kent Tenney growled that the project was too expensive. The proposed locks at the Lake Mendota inlet, above, and dredging of the river would mainly benefit wealthy owners of pleasure boats, Tenney said. His objections were drowned under a flood of public and philanthropic support.

Outlet of Lake Mendota, Madison, Wis.

Some of the strongest support came from boat owners on Lakes Mendota and Monona, who would gain a navigable path between the lakes, and from property owners near the proposed parkway whose property values would increase. The Madison Power Boat Association lobbied for a boathouse along the parkway, and Frank Lloyd Wright offered to design one, but the city council said no.

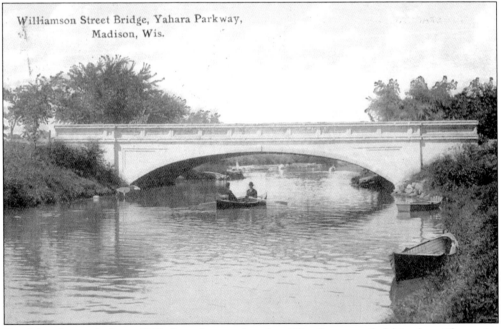

Williamson Street Bridge, Yahara Parkway, Madison, Wis.

Dredging began in June 1903, just six months after Olin first unveiled his plan. The entire project took only three years. The MPPDA raised more than $20,000, not counting donations of land, and the city contributed about $8,000, mostly for bridges, one of which is pictured here. The railroads spent more than $40,000 to raise their four bridges across the river.

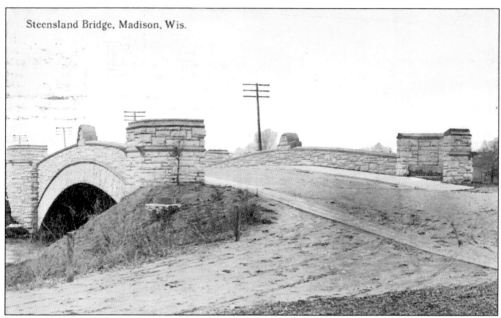

Steensland Bridge, Madison, Wis.

Halle Steensland was a Norwegian emigrant, prominent Madison attorney, developer, and banker, and one of the founders of Madison's Old Norwegian Settlers Union. In 1904, he donated $10,000 to build the Yahara River bridge on East Washington Avenue, shown here, to celebrate his 50 years in Madison. The Steensland Bridge was replaced in 2006.

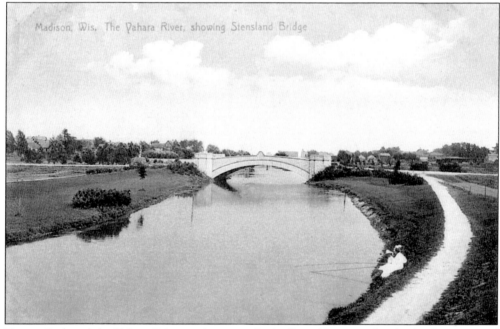

Madison, Wis. The Yahara River, showing Stensland Bridge

Tenney Park and the Yahara River parkway touched off a golden age of parks development and parks philanthropy in Madison. Just a year after dredging began in the Yahara River, William F. Vilas donated $18,000 to expand Wingra Park, Thomas Brittingham gave $8,000 to create a 27-acre park on Monona Bay, and George Burrows and A. H. Hollister made large donations for parks development. By 1917, the MPPDA had received nearly $135,000 in large, private gifts.

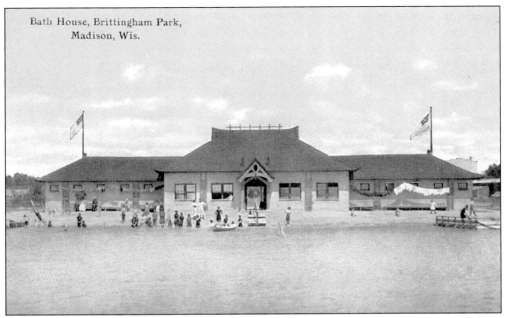

In 1904, Monona Bay was a shallow garbage- and sewage-filled sump, its odor "indescribable." The MPPDA planned a bayside park with beaches, walking paths, and rose gardens. Thousands of tons of sand dredged from the bottom of the bay created a new shoreline. Opened in 1910, the 27-acre Brittingham Park included a public bathhouse (above) for swimmers and a public boathouse to replace the ramshackle private boathouses along the shore.

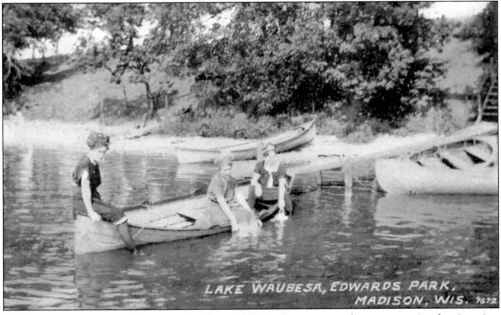

LAKE WAUBESA, EDWARDS PARK, MADISON, WIS. 7672

Swimming in Madison's lakes was illegal until 1879, when a new ordinance permitted swimming if swimmers were clothed "from neck to knee." These young ladies are wearing proper bathing costumes. When the Brittingham bathhouse and other bathing sites opened in the second decade of the 20th century, they were immediate hits. The city provided lifeguards as well as towels and bathing suits, which were passed, still dripping, from one swimmer to the next.

Vilas Park, Madison, Wis.

Henry Vilas Park, seen here, was named for William Vilas's son, who died of diabetes at age 23. Vilas's gift expanded the 24-acre Wingra Park to 64 acres, only a third of which was dry land. Nine years of dredging and dumping sand brought the park to its present size. The MPPDA sponsored free Sunday band concerts beginning in 1914.

A644. SCENE AT VILAS PARK ZOO, MADISON, WIS.

Vilas Park Zoo was created almost by accident. Thomas Richmond, a Madison attorney, offered to give five deer from his south-side farm to the MPPDA in 1910. John Olin suggested they be stabled in Vilas Park on the hillside near Randall Street. Ever the promoter, Olin urged expansion of the menagerie, and it soon included a fox, a raccoon, guinea pigs, rabbits, a red squirrel, white rats, and an eagle.

In 1910, the Vilas family donated another $42,000 for improvements to the park. O. C. Osmonds created the plan for Vilas Park's walkways, plantings, beach, lagoons, and the straightening of Vilas Creek. Black bears, lions, and an aviary were added by the decade's end, and Vilas Park became Madison's flagship public park. The founding of the university's arboretum in 1934 only added to the park's luster.

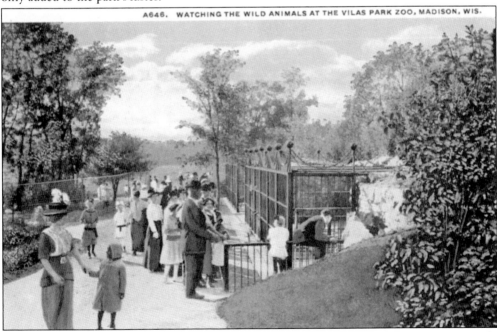

The Vilas family eventually donated nearly $85,000 for the development of Henry Vilas Park, seen here. Their gifts stipulated that no admission should ever be charged for entrance to the park or to the zoo. Operated by Dane County since 1983, Vilas Park Zoo remains one of the few admission-free accredited zoos in the United States.

Boating has always been popular on the four lakes. Motor launches, rowboats, and canoes are seen here at Edwards Park in the village of McFarland on the north end of Lake Waubesa. The first regatta on the lakes—a mass gathering of rowboats and sailboats—was held on July 4, 1855, on Lake Mendota. It drew a crowd of about 3,000 people, nearly a third of Madison's population at the time.

Carl Bernard was one of the most accomplished iceboat skippers in Madison, a city renowned for its iceboaters. Bernard and his family built, raced, and rented iceboats from their boathouse on East Gorham Street. Their 1914 boathouse still stands in James Madison Park. In summer, he rented or chartered boats and took excursions to Bernard's Pleasure Park, seen here, near Governor's Island on the north side of Lake Mendota.

Iceboats have been a feature on Madison's lakes since the mid-1850s. Carl Bernard's grandfather Charles Bernard Sr., a German immigrant, came to Madison in 1954 and began building and racing iceboats. His son William Bernard designed and built a radically new Madison-style iceboat, seen here, that had a raked mast and shorter runners on a central truss design. It would soon dominate races worldwide, reaching speeds up to 125 miles per hour.

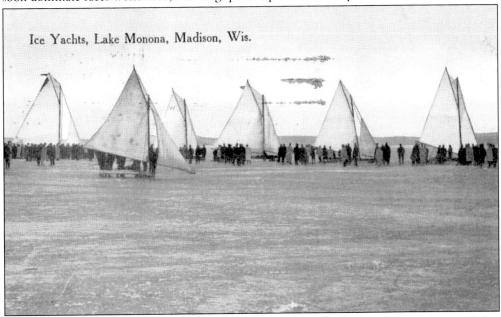

Ice Yachts, Lake Monona, Madison, Wis.

By 1900, there were more than 200 iceboats on the lakes, with intense rivalries between Lakes Mendota and Monona skippers. Madison iceboat skippers like brewer Emil Fauerbach, seen at top, were known worldwide, winning international iceboat competitions in boats built by three generations of Bernards. Fauerbach was a leader in organizing ice regattas, like the one seen here. Madison's lakes attracted iceboat racers and enthusiasts from all over the country.

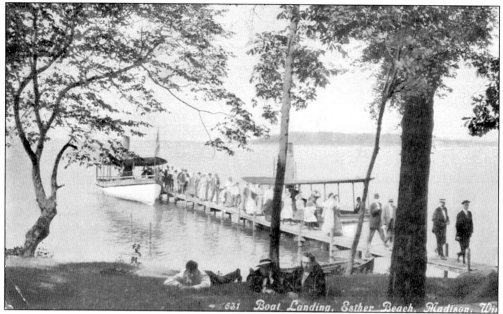

The *Wisconsin State Journal* reported in May 1857, "Everybody owns a boat or a share in a boat." In truth, sailboats and iceboats were costly and rare in the 1850s and 1860s. Madison's real boating boom came after the Civil War, with the influx of tourists. The resorts and parks on Lake Monona were served by steam launches like those seen here at Esther Beach on Monona's south shore.

Lake Monona dominated Madison's tourist trade for many years, with several resorts, parks, beaches, and public and private boat landings. This view is at Esther Beach on the lake's south shore. Lake Mendota was not devoid of tourist traffic. One enterprising skipper set up a tavern on Picnic Point in the 1870s and ferried patrons there aboard a lavishly appointed steam yacht.

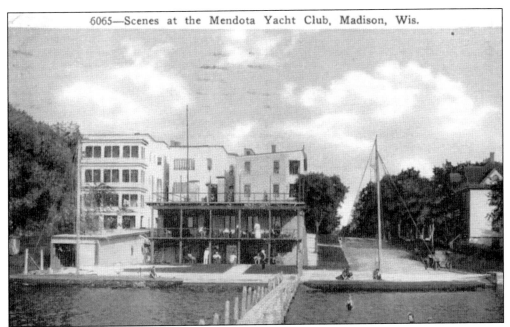

The first sailboat appeared on Lake Mendota in 1839, *Lady of the Lakes*. Two sailboats on the same lake equal a race. By the 1870s, Madison boasted two yacht clubs and an "ice yacht" club. Interest in sailing and iceboating declined in the 1880s, and the clubs disappeared. In 1903, a group of wealthy Madison sailors chartered the Mendota Yacht Club, seen here, at the foot of North Blair Street.

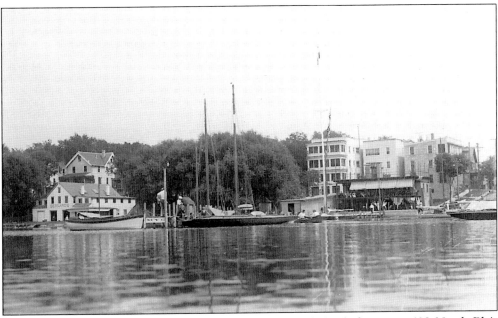

In 1906, the Mendota Yacht Club bought the former soft drink factory at 409 North Blair Street—the large building on the right in this view—and remodeled it for their clubhouse. Bernard's boathouse (see also page 120) is on the left. The clubhouse was demolished in 1970. The boathouse is still in use in James Madison Park.

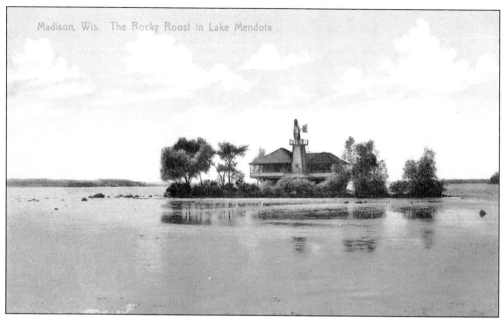

Frank Lloyd Wright designed the private cottage on Rocky Roost Island, seen here from Governor's Island, for his lifelong friend Robert Lamp. Built in 1903, Lamp's cottage replaced two or three older cottages on the little island in Lake Mendota. Lamp and his friends, avid boaters, had been using the island since the early 1890s. The windmill provided fresh water from a well drilled on the island.

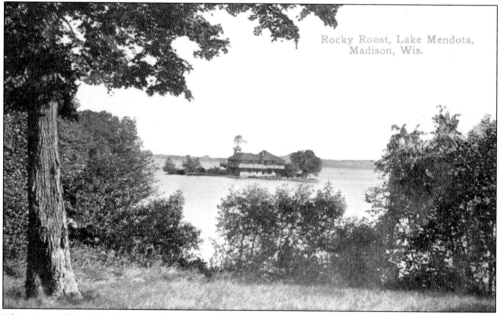

Rocky Roost, Lake Mendota, Madison, Wis.

This view of Rocky Roost is from the Lake Mendota shore, west of Governor's Island. Lamp "discovered" the little island while he was working in Madison's land office in the early 1890s. He and his friends built at least two small cottages and possibly a boathouse there before 1900. Fire destroyed Rocky Roost in 1934. Since then, reeds and other growth have connected Lamp's island to Governor's Island.

Private boaters and commercial excursions visited the "old man of the lake" (upper left)—
Profile Rock at Farwell Point where the Yahara River enters Lake Mendota (lower right) near
Mendota State Hospital. The state insane asylum, Governor's Island, Rocky Roost, and Maple
Bluff were other popular sights and destinations for boaters on Lake Mendota.

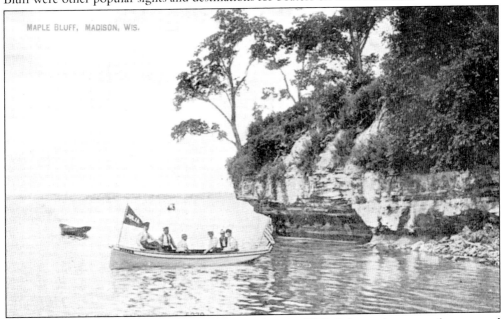

Regular steamboat service began on Lake Mendota in 1877. Private pleasure parks appeared
around the lake and were open to boaters, campers, hikers, and picnickers. Lakeshore camping
was a popular 1870s pastime, and McBride's Point (later Maple Bluff), seen here, was a very
popular spot. The slow boat trip across the lake was part of the adventure, and it made the camp
or picnic site seem more remote that it really was.

In this winter view of University Bay, the University of Wisconsin boathouse is on the lakeshore in front of the armory (Red Gym or Old Red). Behind the armory are Science Hall and the dome of Bascom Hall. The winter of 1880–1881 set the current record for ice on the lake. That winter, Lake Mendota froze over on November 23, and the ice did not break up until May 3, 161 days later.

Madison never became the northern resort city that many hoped for. Nature endowed it with a beautiful setting. If early planners and developers failed to take full advantage of that endowment, later visionaries left the city with more than its share of parkland and open shoreline. Public or private, clean or polluted, fair or storm tossed, Madison's lakes, river, and marshes have left their indelible mark on the city's character.

BIBLIOGRAPHY

American Exchange Bank 100th Anniversary. Madison, WI: American Exchange Bank, 1971.

The Anchor Log. Madison, WI: Anchor Savings and Loan Association, 1964.

Cohen, Saul B., ed. *The Columbia Gazetteer of North America.* New York: Columbia University Press, 2000.

Cook, Diana. *Wisconsin Capitol Fascinating Facts.* Madison, WI: Prairie Oak Press, 1991.

Feldman, Jim. *The Buildings of the University of Wisconsin.* Madison, WI: University Archives, 1997.

Fred, Edwin Broun. *A University Remembers.* Madison, WI: University of Wisconsin, 1969.

Levitan, Stuart D. *Madison, The Illustrated Sesquicentennial History, Vol. 1.* Madison, WI: University of Wisconsin Press, 2006.

"Madison Past & Present, 1852–1902." *Wisconsin State Journal.* Madison, WI: 1902.

Mollenhoff, David V. *Madison, A History of the Formative Years.* Dubuque, IA: Kendall/Hunt Publishing Company, 1982.

Rogue, Allan G. and Robert Taylor, eds. *The University of Wisconsin, One Hundred and Twenty-five Years.* Madison, WI: University of Wisconsin Press, 1975.

www.historicmadison.org.

www.mononaterrace.com.

DISCOVER THOUSANDS OF LOCAL HISTORY BOOKS
FEATURING MILLIONS OF VINTAGE IMAGES

Arcadia Publishing, the leading local history publisher in the United States, is committed to making history accessible and meaningful through publishing books that celebrate and preserve the heritage of America's people and places.

Find more books like this at
www.arcadiapublishing.com

Search for your hometown history, your old stomping grounds, and even your favorite sports team.